READY TO PAINT

Watercolour
Boats and Harbours

Charles Evans

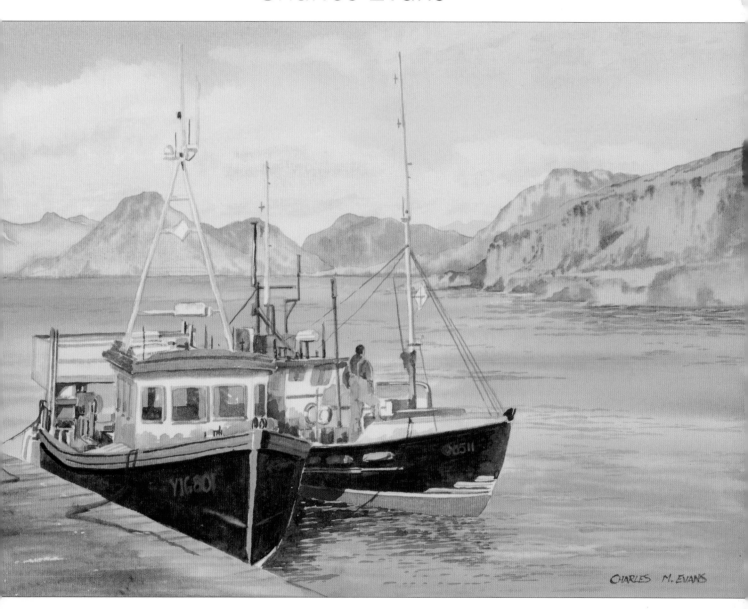

SEARCH PRESS

First published in Great Britain 2008

Search Press Limited
Wellwood, North Farm Road,
Tunbridge Wells, Kent TN2 3DR

Reprinted 2009 (twice), 2010, 2012

Text copyright © Charles Evans 2008

Photographs by Roddy Paine Studios

Photographs and design copyright © Search Press Ltd 2008

ISBN: 978-1-84448-332-7

The Publishers and author can accept no responsibility for any
consequences arising from the information, advice or instructions given
in this publication.

Readers are permitted to reproduce any of the tracings or paintings
in this book for their personal use, or for the purposes of selling
for charity, free of charge and without the prior permission of the
Publishers. Any use of the tracings or paintings for commercial
purposes is not permitted without the prior permission of
the Publishers.

Suppliers
If you have any difficulty obtaining any of the materials and equipment
mentioned in this book, please go to the Search Press website:

www.searchpress.com

Publisher's note
All the step-by-step photographs in this book feature the author,
Charles Evans, demonstrating his watercolour painting techniques.
No models have been used.

There are references to sable and other animal hair brushes in this
book. It is the Publishers' custom to recommend synthetic materials
as substitutes for animal products wherever possible. There is now a
large range of brushes available made from artificial fibres, and they are
satisfactory substitutes for those made from natural fibres.

**Please note: When removing the perforated sheets of tracing paper
from the book, score them first, then carefully pull out each sheet.**

For further projects, stage-by-stage paintings and art materials, you can
visit the author's website at: www.charlesevansart.com

Printed in China

Dedication

This book is dedicated to all the people I
have met on my travels whilst doing the most
privileged job in the world: all my fellow painters
and the people who watch the TV programmes
and come to my shows.
Also to Brett, my business partner and P.A.,
without whom I wouldn't know where I'm going
most of the time.

Acknowledgements

I would like to thank all at Search Press for their help
in the creation of this book, especially Edd the editor
for his never-ending patience when I threw a strop, his
seemingly endless knowledge of nautical terms and
his unfailing efforts to keep the music going in the
photography studios (shame about his dancing).
Also a big thank you to Winsor & Newton for their
support and fabulous materials.

Page 1:
Scottish Fishing Boats
500 x 325mm (19¾ x 12¾in)
*This painting is provided as a bonus
tracing in the centre of the book.*

Opposite:
Pin Mill, Suffolk
500 x 325mm (19¾ x 12¾in)

1

Contents

Introduction 4

Materials 6

Transferring the image 9

Newquay 10
 Step by step

Pin Mill 18
 Step by step

Alnmouth Estuary 26
 Step by step

St Ives 34
 Step by step

Norfolk Wherry 42
 Step by step

Index 48

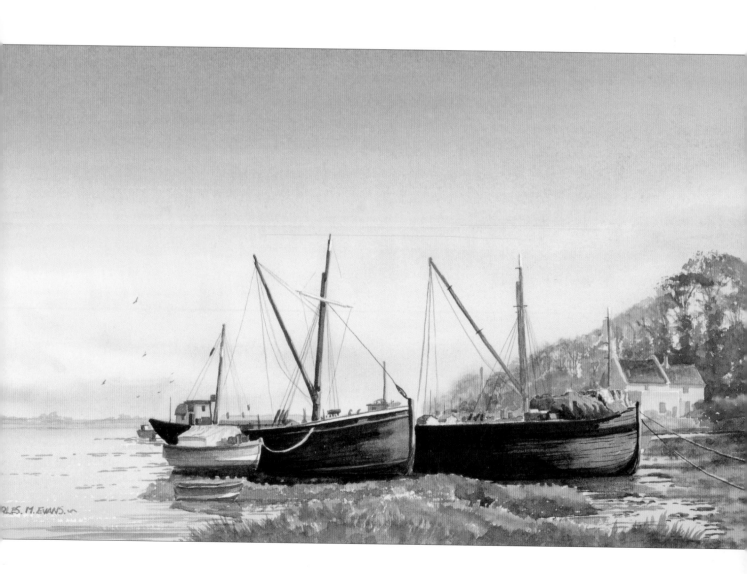

Introduction

The title of this book would suggest that it involves a lot of very difficult and complex drawing, and to be honest boats are not the easiest of subjects to draw. However, that is the last thing you need to worry about because this book provides the drawings ready for you to simply trace and paint.

In my travels up and down the country (and indeed around the world) I am told many, many times 'I would love to paint but I can not draw anything to save my life.' In this book that worry is taken away, leaving you to concentrate on your colour mixing and the many tips and techniques that you will gather in this publication.

I have painted for as long as I can remember and have always marvelled at the mastery shown by such great artists as Turner and Constable, and have also been amazed by the wonderful figures and granulation achieved in the works of Sir William Russell Flint. In addition to these great masters I find the works of Edward Seago enchanting, evocative and successful in capturing the mood and feel of the English countryside. I mention these artists because they have been my inspiration for many years and there is nothing wrong with copying other artists' work to try and figure out how they achieved their effects. I do not class myself with any of the aforementioned, but I hope this book fills you with the same enthusiasm to get painting as these artists inspired in me.

Watercolour is often thought of as the most difficult medium because once you make a mistake you can not put it right. My aim has always been to demystify watercolour painting and to make it accessible to everyone. My theory in life is that everyone should have a go at painting, as I believe it is the biggest stress-buster around: when you concentrate your mind on painting it takes over from everything else in the day.

Above all, do not worry – painting is about fun. So, with very few brushes and very few paints, let's have some fun together. Get ready to paint!

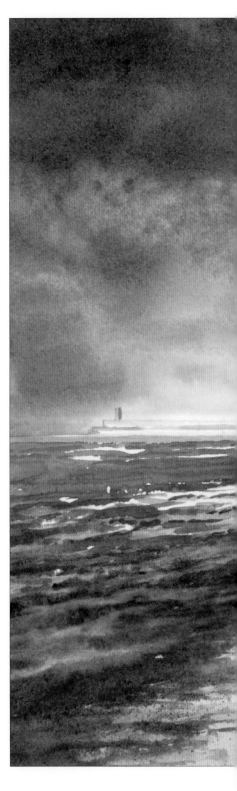

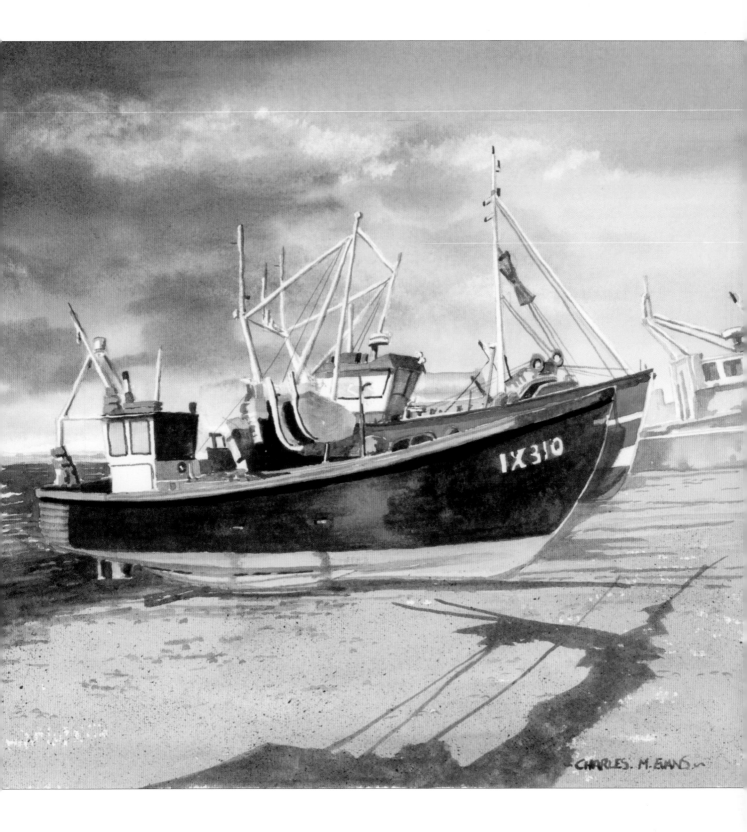

Hastings Beach

500 x 325mm (19¾ x 12¾in)

The strong dark sky emphasises the light tones on the boats, making a striking picture.

Materials

Paints

I always use artists' quality watercolour paints because they have a more permanent colour made from natural pigments; as opposed to students' quality, some of which contain synthetic pigments, and are less permanent. I use Winsor & Newton paints, which have been used by professional and amateur alike for centuries. Made from only the finest materials, my paintings will still be on the paper long after I am gone!

I have always used tubes as opposed to pans because I paint outdoors a lot of the time. Imagine the scene: you have pre-wet the big sky area, and have a very large brush in your hand, desperately trying to scrape paint into your mixing areas from a small pan before it all dries on you. With tubes, you can simply squeeze out the paint and add water. Much less stressful!

Brushes

There are countless different types of brush on the market. I use Winsor & Newton Cotman III series synthetic brushes because they are very sturdy and will stand up to all the abuse that I give them. They will carry a lot of paint, and they are cheaper than sable brushes.

I find pure sable brushes are too soft and will not carry as much paint as synthetic.

You do not need a vast range of brushes. In this book, I use only four: a large flat brush such as a 38mm (1½in) or 5cm (2in) for large washes, a 20mm (¾in) flat brush for smaller washes and blocking in large areas, a size 8 round for the details, and an old size 3 rigger for applying wmasking fluid.

Paper

There are lots and lots of different types of paper, some very expensive! The paper I use is Winsor & Newton 300gsm (140lb) in weight, with a very hard working surface. This means that I do not have to pre-stretch, and it will not cockle when wet, unlike some other 300gsm (140lb) papers. It will always dry flat.

I prefer using paper with a rough surface which gives a nice textured effect to the paintings.

Other materials

In addition to brushes, paints and paper, I use some other pieces that are either essential, or make my life a little easier.

Easel I prefer to stand when I am painting and an easel keeps the painting upright as I work.

Bulldog clips and board I use bulldog clips to secure my paper to the board so the painting does not slip out of place.

Masking tape Adding a border of masking tape round the edge of your paper ensures a crisp, clean finish to your work.

Bucket and hook A big bucket means that you do not have to run off every five minutes for clean water, and the hook (a simple meat hook) allows you to hang it from the easel for ease of use.

Soft pencil and an eraser A soft pencil is used to trace the pictures to transfer them to your paper. The eraser is there just in case!

Masking fluid, old brush, soap and pot of water Masking fluid is applied with the old brush. Make sure to use a separate pot of water to avoid polluting your bucket. The soap allows you to clean the brush.

Palette I use the metal mixing palette in my paint box to prepare wells of paint.

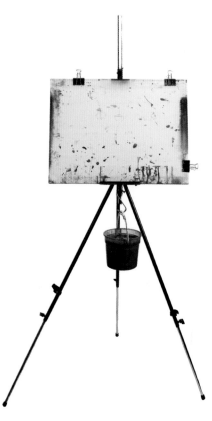

Tip

Masking fluid can be bought ready-tinted, which helps you to see exactly where it is.

Transferring the image

Pull out the tracing you want to use from the front of the book, and follow the instructions below to transfer the image to your watercolour paper.

I have used a spoon handle to transfer the image, but a burnishing tool or the lid of a ballpoint pen would also work.

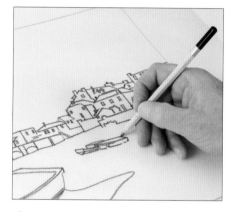

1 Place your tracing face-down on some scrap paper. Go over the lines on the back using a soft pencil. This is a section from the St Ives project (see pages 34–41). You will be able to reuse this tracing several times without going over the pencil lines again.

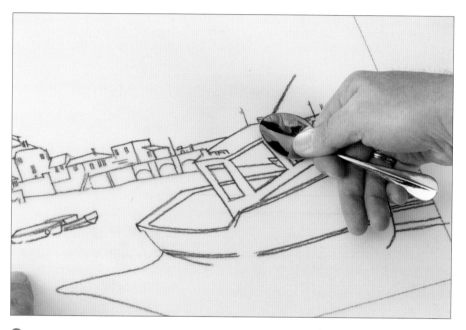

2 Tape a sheet of A3 watercolour paper down on a board, and place the tracing face-up on top. Tape down the top of the tracing only. Use the handle of a spoon to go over the lines.

3 You can lift up the tracing from the bottom as you work, to see how the transfer of the image is going.

Newquay

This is a strong painting, with an overall warm feel owing to the colours used in the mixes. You will notice that I use the same blue in the sea as I do in the sky and this is a handy rule of thumb that will make sure the colours in your paintings look natural.

You will need

500 x 325mm (19¾ x 12¾in) rough finish 300gsm (140lb) watercolour paper

Colours: yellow ochre, alizarin crimson, cobalt blue, Hooker's green, raw umber, light red, burnt sienna, cadmium red and French ultramarine

Brushes: 38mm (1½in) flat, 20mm (¾in) flat, size 3 rigger and size 8 round

Masking fluid and soap

Masking tape

1 Transfer the picture to your paper (see page 9) and use masking tape to secure it to your board. Use the size 3 rigger to apply masking fluid to the areas shown, and allow it to dry.

Tip

Run your rigger through wet soap before applying the masking fluid, and rinse thoroughly once you have finished.

2 Use the 38mm (1½in) flat brush to apply clean water over the sky area. Apply plenty of water: just enough to wet the paper without dripping straight off. Use a mix of yellow ochre and alizarin crimson to paint the lower half of the sky.

3 Clean your brush and remove excess water from it by tapping it on the side of your water pot. Draw the damp bristles across the horizon to remove any beads of paint that have formed.

4 Still working wet-into-wet, apply cobalt blue from the top down over the entire sky. Allow it to bleed into the horizon colour.

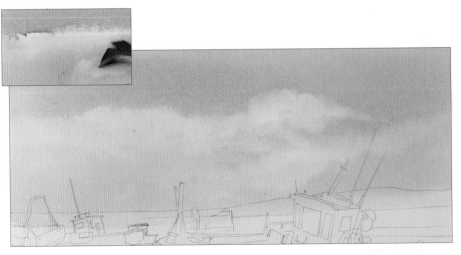

5 Clean your brush and remove excess water, then use it to lift out clouds with the side of the 38mm (1½in) flat brush as shown. Make sure it is damp but not wet. Allow to dry.

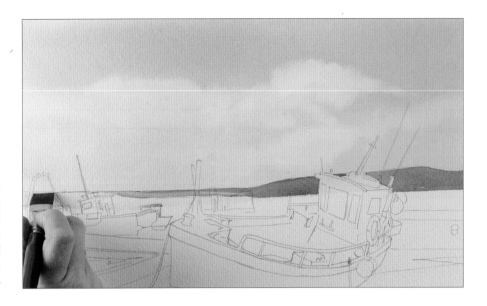

6 Mix cobalt blue with a touch of alizarin crimson, and use a 20mm (¾in) flat brush to paint in the background hills. Use the corner of the brush to paint around the corners of the boats and other sharp angles.

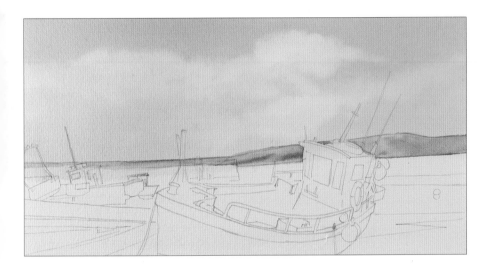

7 Quickly clean and rinse the 20mm (¾in) flat brush, then use it to lift out some highlights on the background hills.

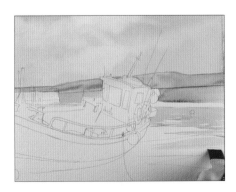

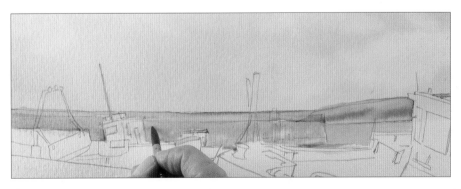

8 Still using the 20mm (¾in) flat brush, use a mix of cobalt blue and Hooker's green to paint in the water in the middle distance. Leave white patches as you advance to add detail to the foreground.

9 Change to the size 8 round brush and wet the pier in the background with clean water. Add a touch of raw umber to yellow ochre, and use this to paint the pier.

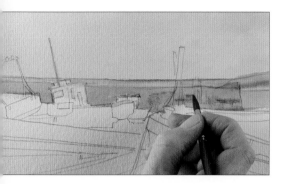

10 Working wet-into-wet, work spots of light red and raw umber to warm the colour.

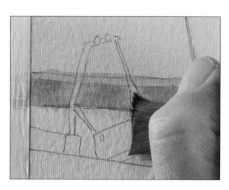

11 Lift out the rigging by running the edge of the damp 20mm (¾in) flat brush down each piece.

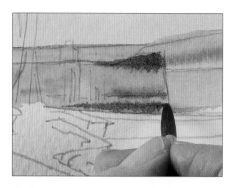

12 Make a shadow mix of cobalt blue, alizarin crimson and burnt sienna, and use the size 8 round brush to add shading to the right-hand end of the pier.

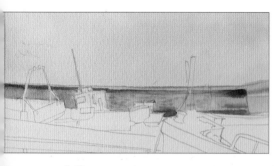

13 Continue adding detail to the pier using the shadow mix. Dilute the mix with more water and use this for further texture.

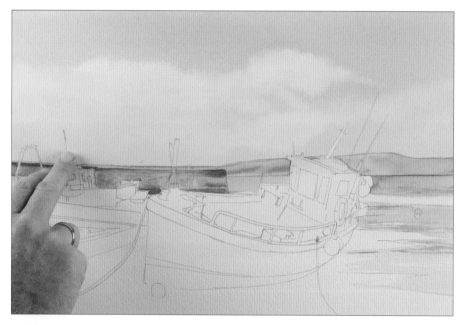

14 Allow the whole painting to dry thoroughly, then use the tip of a clean finger to gently rub all of the masking fluid away.

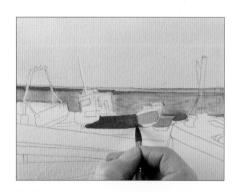

15 Use the size 8 round brush with cobalt blue to paint the central boats in the middle distance. Add more water to vary the tones.

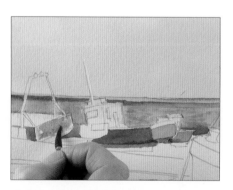

16 Use a mix of yellow ochre and raw umber to paint the mud in and around the blue boats, then add water to the mix and use this to paint the rear of the left-most boat.

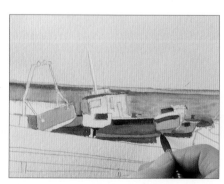

17 Build detail on the blue boats with alizarin crimson. Mix cobalt blue, alizarin crimson and burnt sienna, and use this shadow mix to add shading to the boats.

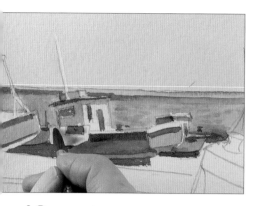

18 Use pale cobalt blue to paint the shaded side of the cabin and the other white areas.

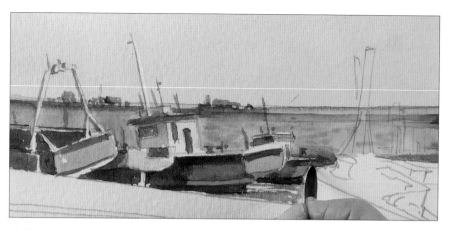

19 Add detail to tighten the mid-distance area with various tones of the colours used earlier. Use the shadow mix (cobalt blue, alizarin crimson and burnt sienna) with the tip of the size 8 round brush to add the rigging and fine details to the boats, then fill in the small area below the boats with a mix of cobalt blue and Hooker's green.

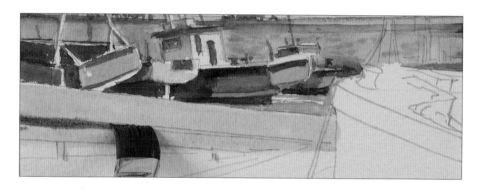

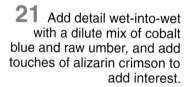

20 Wet the jetty with the 20mm (¾in) flat brush and paint it with a mix of yellow ochre and raw umber. Add a mix of raw umber and cobalt blue to shade the area.

21 Add detail wet-into-wet with a dilute mix of cobalt blue and raw umber, and add touches of alizarin crimson to add interest.

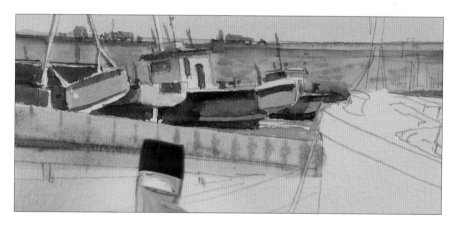

22 Paint the reflection of the jetty with the same colours, but do not pre-wet the paper. This will make the reflection slightly darker than the jetty itself. Working wet-into-wet, use the shadow mix to paint shades and details on the jetty and reflection.

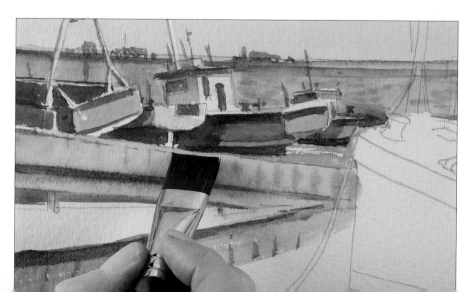

13

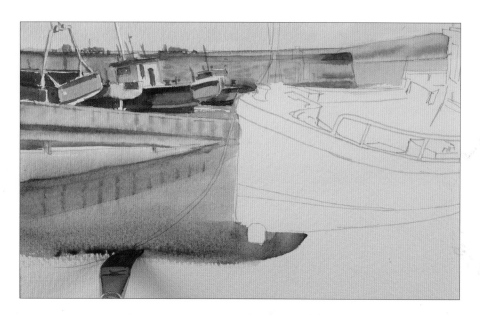

23 Allow to dry, then wash a dilute mix of cobalt blue and Hooker's green over the jetty's reflection and the area around the lower left.

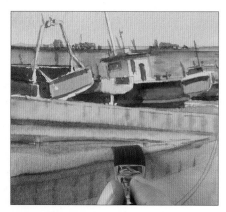

24 Paint the sand beneath the jetty with yellow ochre and raw umber mixed in wet-into-wet.

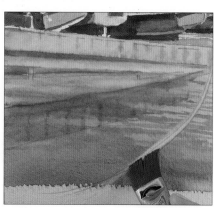

25 Add burnt sienna to a mix of cobalt blue and Hooker's green and add ripples in the water with the side of the 20mm (¾in) flat brush. Clean and rinse it, and lift out the rope with the damp edge.

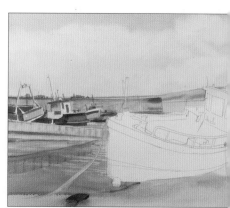

26 Dilute a mix of yellow ochre and raw umber and paint over the foreground. Add a stronger mix wet-into-wet to detail the sand.

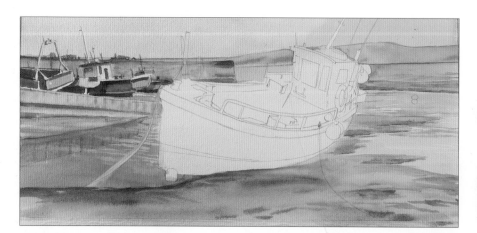

27 Still using the 20mm (¾in) flat brush, use raw umber in the foreground to add texture and interest. Add very wet cadmium red below the boat for the boat's reflection. Finally, add touches of the shadow mix (cobalt blue, alizarin crimson and burnt sienna) wet-into-wet.

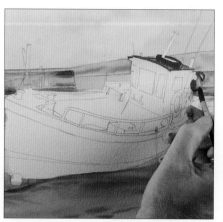

28 Switch to the size 8 round brush and use cadmium red to block in the cabin roof and buoys. Lift out some of the paint with clean water to create highlights.

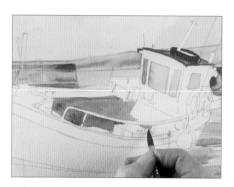

29 Paint the windows with cobalt blue with a touch of burnt sienna, then use pure cobalt blue to paint the inside of the boat. Work carefully around the railings.

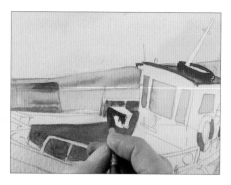

30 Use cadmium red for the lifebelts, then strengthen the blue with a second wash once the first is dry. Use cobalt blue and raw umber to paint the boxes at the back.

31 Use yellow ochre to paint the gunwale, then lift out the areas in direct sunlight. Use a more dilute mix to paint the top of the gunwale.

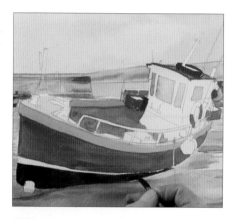

32 Paint the main hull with cadmium red, then paint the bottom of the hull with a very dark mix of French ultramarine and burnt sienna. Allow to dry thoroughly.

33 Add shading and detail to the interior of the cabin and the buoys with cobalt blue, then add a touch of alizarin crimson and paint the aerials. Use burnt sienna and some of the shadow mix used earlier to paint the box at the front.

34 Paint the mooring post at the front with a mix of burnt sienna and raw umber. Use the shadow mix wet-into-wet for the parts in shade. Use burnt sienna to detail the railing, leaving white spaces showing on the top for highlights.

35 Mix French ultramarine with burnt sienna for a black paint, and use this to add the deepest shades. Paint the posts behind the boat with burnt sienna, and shade with the black mix.

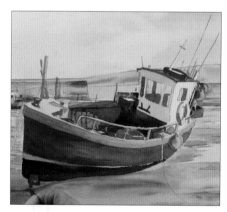

36 Paint over the inside of the boat with the shadow mix, then soften it with a damp brush. Paint a wash of dilute shadow over the main hull for shading, then paint the buoy with cadmium red.

37 Make a stronger shadow mix by adding more burnt sienna. Use this to strengthen the shading across the whole boat.

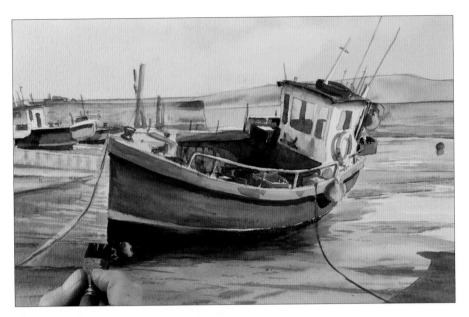

38 Use the size 8 round brush to paint details such as the buoy in the mid-distance with burnt sienna and shadow mix. Switch to the 20mm (¾in) flat brush to lift out the ropes before painting them with a mix of yellow ochre and burnt sienna and shading them with the black mix.

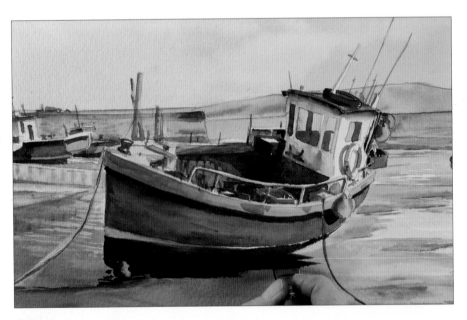

39 Use the 20mm (¾in) flat brush with a fairly strong shadow mix to paint the shadow of the boat on the sand and water. Quickly rinse your brush and use it to break up the shadow.

Tip
Birds make a good addition to a painting, helping to make a clear sky more interesting. Make sure that you always use an odd number, and do not make them too big!

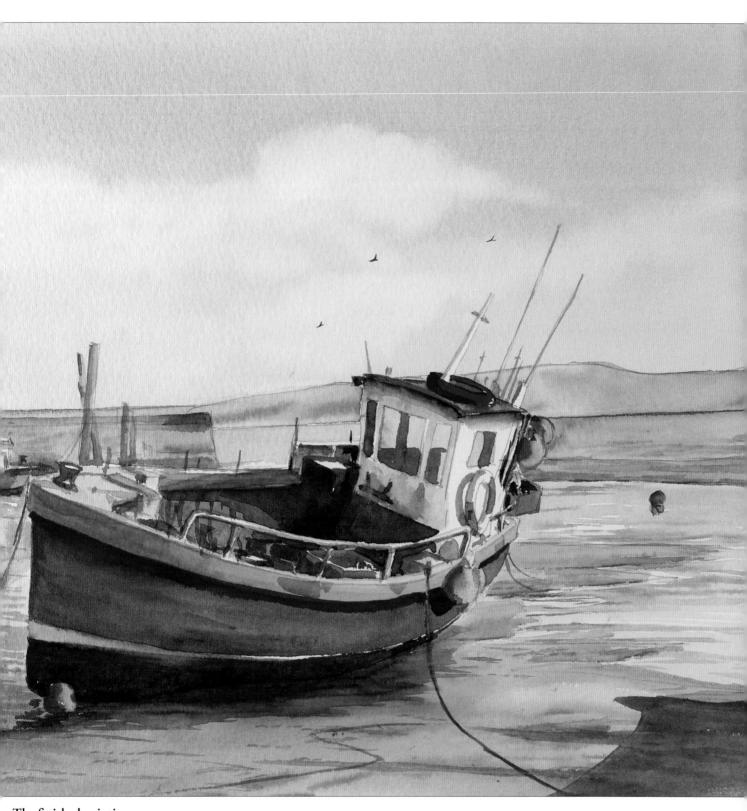

The finished painting

*The shadow of a boat off to the right has been added,
along with a few birds.*

Pin Mill

Pin Mill is one of my favourite Suffolk locations. The old boats that often moor here mean that it is always a timeless scene.

You will need

500 x 325mm (19¾ x 12¾in) rough finish 300gsm (140lb) watercolour paper

Colours: yellow ochre, alizarin crimson, cobalt blue, Hooker's green, raw umber, light red, French ultramarine and burnt sienna

Brushes: 38mm (1½in) flat, 20mm (¾in) flat, size 3 rigger and size 8 round

Masking tape

1 Transfer the tracing to your paper, and secure it to the board with masking tape. Prop it up in your easel, then use the 38mm (1½in) flat brush to wet the top half of the picture. Paint yellow ochre over the lower half.

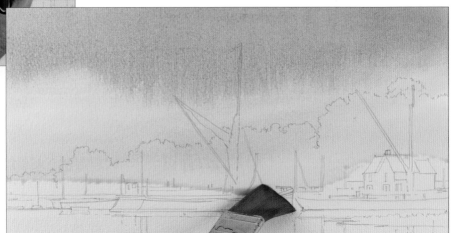

2 Rinse your brush, then add cobalt blue wet-into-wet from the top down. Clean your brush, then draw it across the horizon line to lift away any paint that forms beads here.

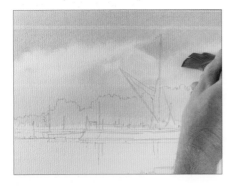

3 Clean your brush and tap off any excess water. Use the clean damp brush to lift out clouds with a diagonal movement.

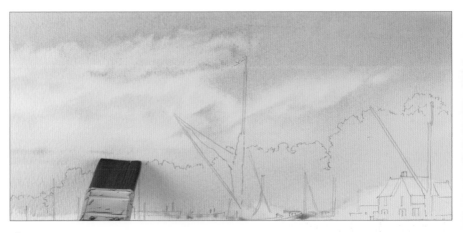

4 Add alizarin crimson to cobalt blue, and use this to add warm shadows to the bottom of the clouds. Soften with a damp brush, and allow to dry.

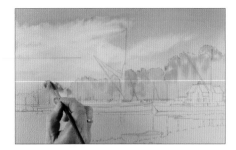

5 Use the size 8 round brush to wet the trees, being careful not to overlap the buildings. Add yellow ochre wet-into-wet along the top.

Tip

I never use Hooker's green on its own, as it is very synthetic looking.

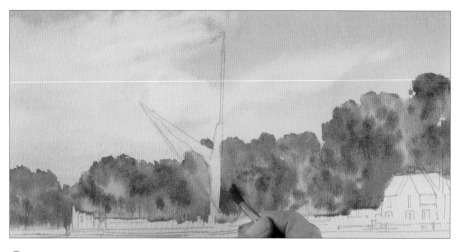

6 Add Hooker's green to yellow ochre, and add wet-into-wet along the treeline. Make a mix of Hooker's green and burnt sienna and drop it in wet-into-wet along the lower parts of the trees. To complete this area, add touches of pure burnt sienna to add texture as shown.

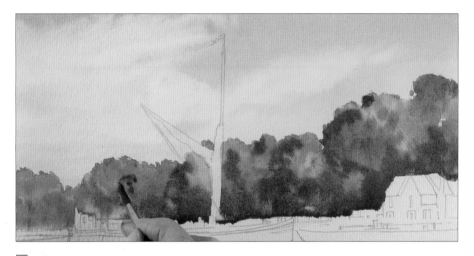

7 Mix cobalt blue with a touch of light red, and use this mix to paint along the base of the trees, particularly round the pub on the lower right. Stipple shading on the left-hand sides of the trees with the same mix for shadows in the foliage.

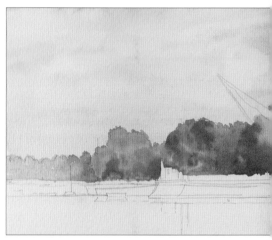

8 Paint the trees in the distant background with cobalt blue, blending them into the wet foreground trees. Allow to dry.

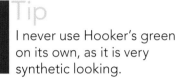

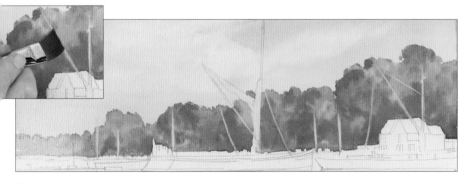

9 Wet the 20mm (¾in) flat brush, then use the edge (see inset) to lift out the masts along the treeline.

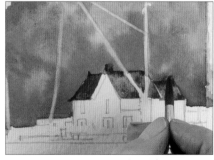

10 Use the size 8 round brush to block in the pub roof with burnt sienna. Add raw umber to the mix on the left as this area is shaded. Note the thin white space between the roof sections on the right.

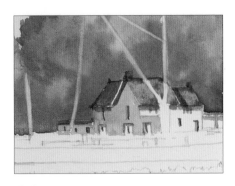

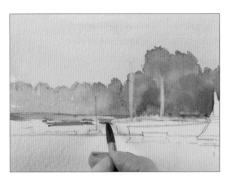

11 Use dilute cobalt blue to paint the shaded part of the pub. Add burnt sienna to cobalt blue and paint the windows and details on the pub. Use a mix of cobalt blue and alizarin crimson to add the deepest shades.

12 Switch to the left-hand side of the picture and paint yellow ochre below the area where the background trees meet the horizon line. Add a mix of burnt sienna and Hooker's green wet-into-wet.

13 Use a mix of cobalt blue and light red to suggest hints of boats in the background. Add a shadow mix (cobalt blue, burnt sienna and alizarin crimson) to outline and to add the masts.

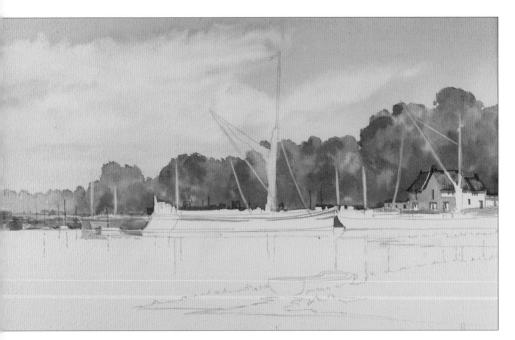

14 Use a mix of burnt sienna and Hooker's green for the lawn in front of the pub, then add more light red to the cobalt blue and light red mix to make it darker and stronger. Use this to add some strokes behind the main boats to suggest boats in the mid-distance behind them. Still using the size 8 round brush, paint thin stripes of yellow ochre across the central boat.

15 Mix black from French ultramarine and burnt sienna, and use it to paint the main boat, letting some of the yellow ochre show through. While still wet, add strokes of light red.

16 Lift out some of the black to represent reflections from the water's surface, then paint the waterline with a narrow stripe of light red. Paint a second, broken stripe as the reflection.

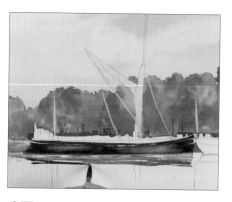

17 Continue adding to the reflection with broken strips of a diluted black mix below the red stripe. Leave hints of white paper showing through here and there.

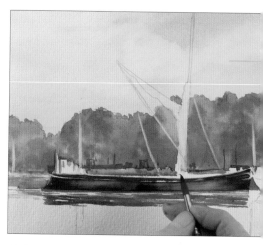

18 Use cobalt blue to detail the cabin of the main boat, then use yellow ochre for the cargo. Add burnt sienna wet-into-wet to add interest and detail.

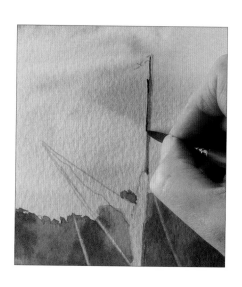

19 Paint the mast with a raw umber and burnt sienna mix. Add shading wet-into-wet with the shadow mix.

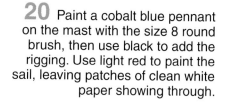

20 Paint a cobalt blue pennant on the mast with the size 8 round brush, then use black to add the rigging. Use light red to paint the sail, leaving patches of clean white paper showing through.

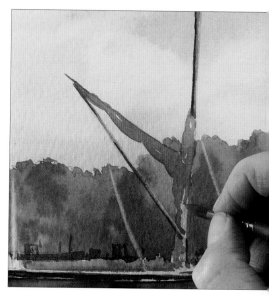

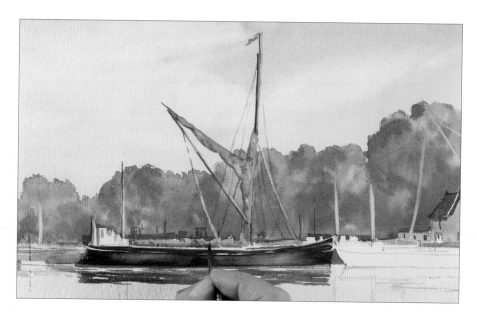

21 Work in shadow mix wet-into-wet on the lower left side, then lift out some areas to add texture. Add more rigging with dilute mix of the shadow mix.

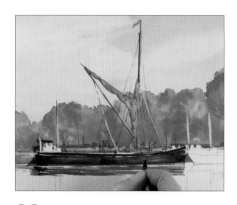

22 Use burnt sienna to paint the roof of the cabin, then add detail to the hull with narrow stripes of the shadow mix.

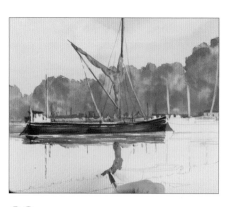

23 Use light red to paint the reflection of the sail, yellow ochre for the reflection of the cargo, and shadow to detail these reflections.

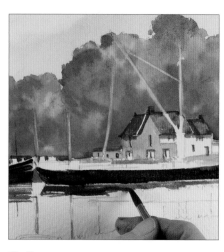

24 Use burnt sienna with shadow added wet-into-wet for shading to paint the masts and reflections of the masts of the background boats. Mix French ultramarine and burnt sienna for a black mix, then use this to block in the hull and reflection of the right-hand boat. Add light red to the mix to vary the hue.

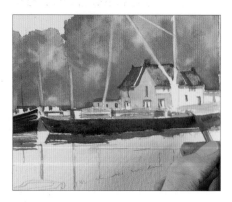

25 Mix raw umber with burnt sienna and paint the cargo on the right-hand boat. Use yellow ochre to vary the cargo.

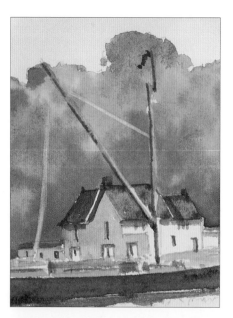

26 Use yellow ochre with a touch of raw umber to paint in the masts. Leave a sliver of white paper showing through on the right as a highlight. Use the black mix to add shading on the left, then add a pennant with cadmium red.

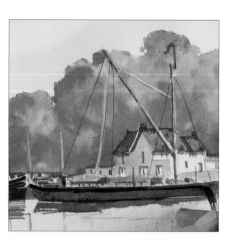

27 Use the size 3 rigger to paint in the rigging with the black mix, then break up the cargo using the black mix and the size 8 round brush. You need less detail here than on the main boat, so do not be too fussy.

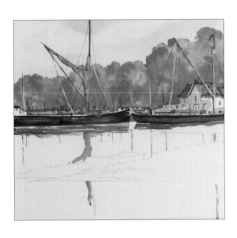

28 Paint the reflection of the right-hand boat's mast using raw umber and yellow ochre.

29 Make a very dilute wash of cobalt blue with a touch of light red. With quick, light strokes of the 20mm (¾in) flat brush, paint the river, leaving white patches showing through. Use a light touch and quick movements to avoid muddying and spoiling the picture – no pressure!

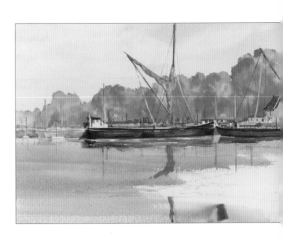

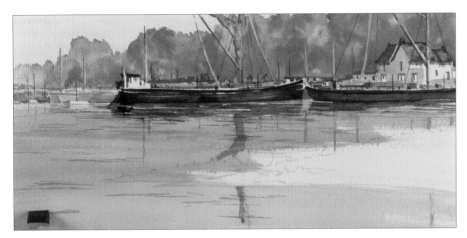

30 Use a stronger mix to add ripples and wavelets with the side of the 20mm (¾in) flat brush. Make them dark where the boats meet the water.

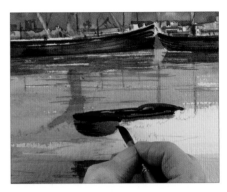

31 Use the size 8 round brush with a strong mix of cobalt blue to paint in the top of the foreground boat. Paint the parts in shadow with a cobalt blue and light red mix, and paint the inside with the black mix. Use the same mixes for the reflection.

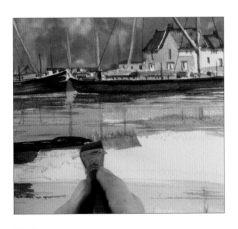

32 Use the 20mm (¾in) flat brush with a mix of yellow ochre and Hooker's green for grasses. Short upward strokes give a textured effect.

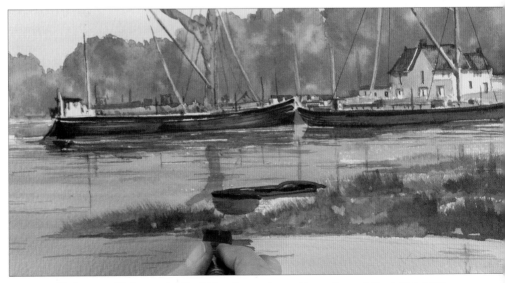

33 Add burnt sienna to the green mix for darker shades, and continue filling in the grassy area, right to the edge of the paper. Add cobalt blue and light red to the mix to give further dark contrasts.

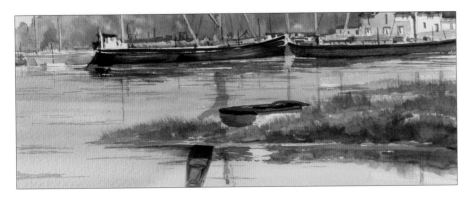

34 Paint in the reflection of the grass, using the edge of the 20mm (¾in) wash brush with a mix of burnt sienna and Hooker's green. Work cobalt blue and light red into the mix to vary the colour.

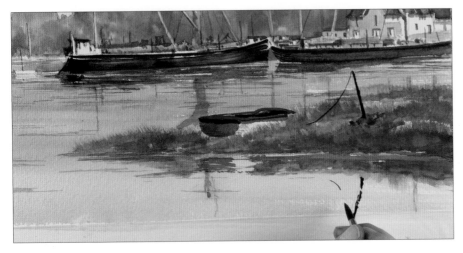

35 Use the black mix (French ultramarine and burnt sienna) to paint a mooring post, line and reflection next to the foreground boat.

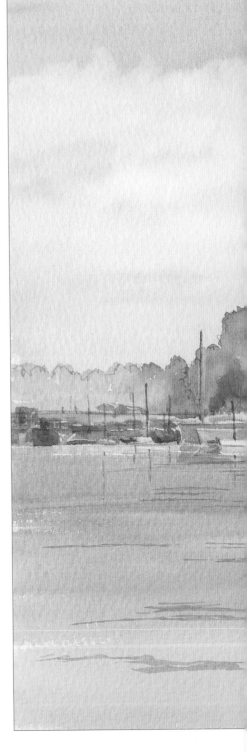

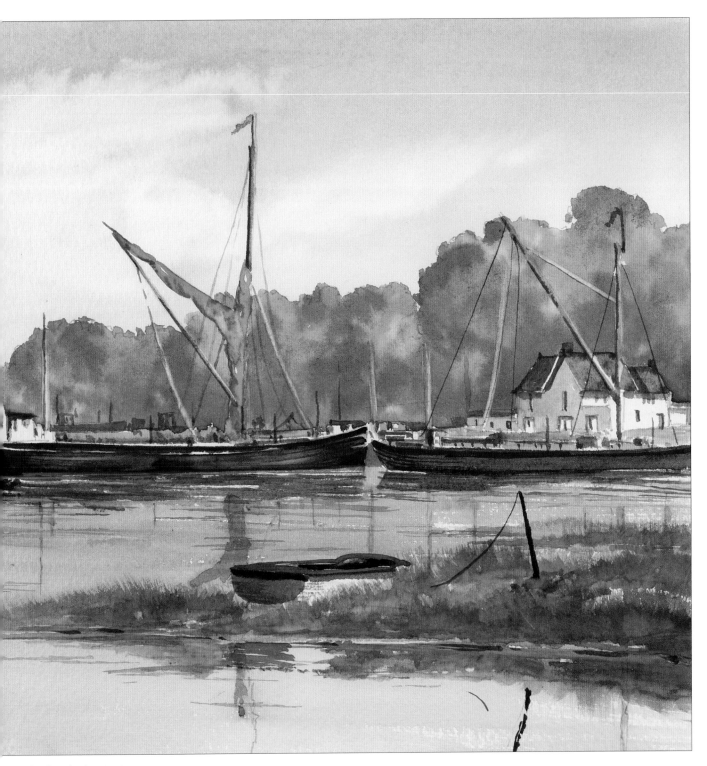

The finished painting

Pin Mill is a location that will always inspire you to paint.

Alnmouth Estuary

There are a lot of strong colours used in this painting, but do not worry, it will look fantastic once you are finished. Trust me, I'm an artist!

You will need

500 x 325mm (19¾ x 12¾in) rough finish 300gsm (140lb) watercolour paper

Colours: yellow ochre, cadmium yellow, cobalt blue, light red, Hooker's green, raw umber, French ultramarine, burnt sienna, alizarin crimson and cadmium red

Brushes: 38mm (1½in) flat, 20mm (¾in) flat and size 8 round

Kitchen roll

Masking tape

1 Transfer the picture to the watercolour paper, then secure it to the board with masking tape. Wet the water and sky using the 38mm (1½in) flat brush, and drop in yellow ochre. Add light red wet-into-wet to vary the colour.

2 Add a patch of cadmium yellow into the sky, then twist kitchen roll into the centre to lift out a circle.

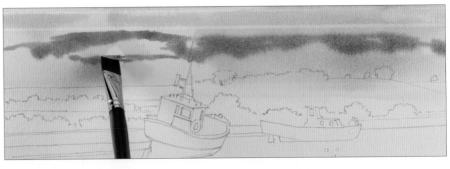

3 Make a cobalt blue and light red mix, and use the 20mm (¾in) flat brush to add clouds wet-into-wet.

Tip

Remember to take the clouds in front of the lifted-out sun. Even the great Turner forgot to do this once!

4 Use the same colour to add the reflections of the clouds in the water, then soften the colours into one another with a clean wet brush.

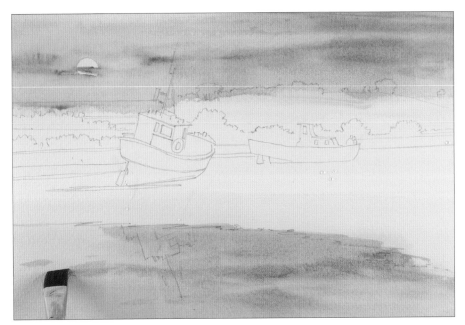

5 Add yellow ochre across the water, then add light red at the edge of the sand wet-into-wet. Restate the clouds in the sky and their reflections in the water with a cobalt blue and light red mix.

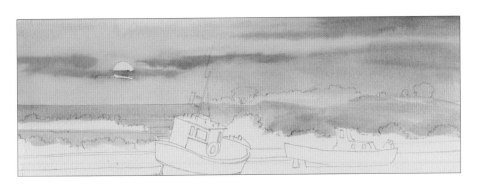

6 Use a weak wash of a Hooker's green and yellow ochre mix to paint the background hills, diluting it further for the more distant hills.

7 Use a mix of raw umber and light red to shape the hills with light diagonal strokes.

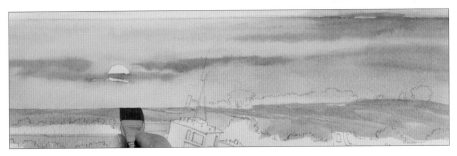

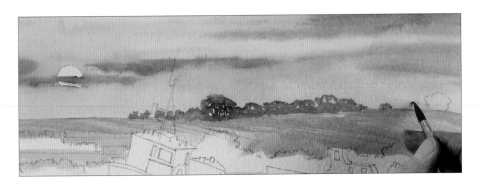

8 Stipple silhouetted trees on to the horizon using the size 8 round brush with a mix of cobalt blue and light red. Make small vertical strokes at the bottom for the trunk. Make sure to leave some gaps between the trunks of the trees: you do not want the birds to break their necks!

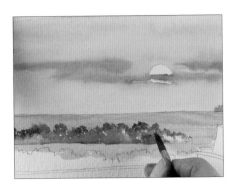

9 Use the same mix of cobalt blue and light red to paint bushes in the mid-distance on the left. Again, leave areas of undergrowth showing through.

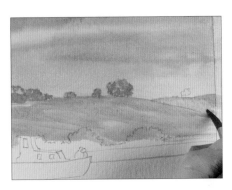

10 Add a touch more cobalt blue to the mix and use a dilute wash to add the hill in the top right.

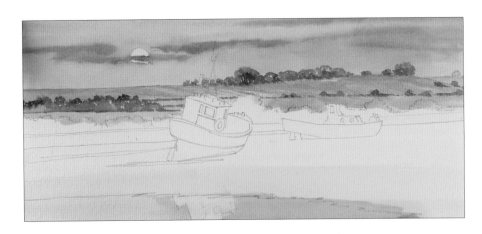

11 Paint some hedgerows on the mid-distance hills with the same mix, then strengthen the background trees with a glaze of the original colour once they have dried to finish the background.

12 Mix a fairly strong mix of cobalt blue and light red and use it with the size 8 round brush to paint the foreground bushes. Rather than using brushstrokes, stipple the paint on, as this will give a more realistic and natural look to the foliage.

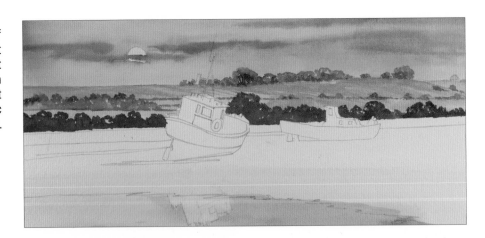

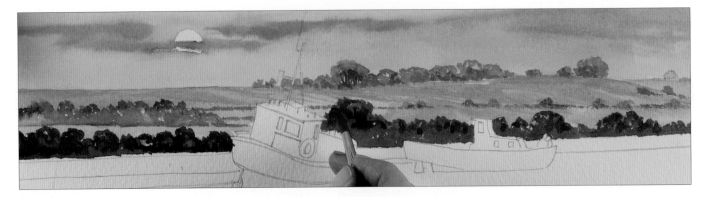

13 Warm the foreground bushes with burnt sienna, then soften the colour with a clean damp brush.

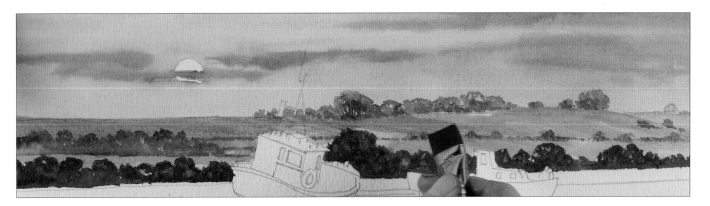

14 Use the 20mm (¾in) flat brush with a very dilute mix of cobalt blue to glaze the background hills. This softens and knocks the colours back.

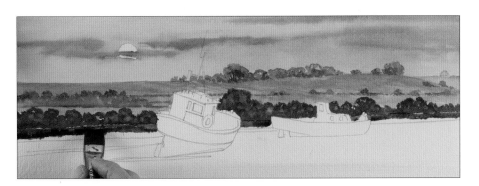

15 Add Hooker's green to burnt sienna and use the 20mm (¾in) flat brush to paint the hedge below the foreground bushes. Add in a mix of cobalt blue and light red wet-into-wet for shading.

16 Draw the bottom of the hedge down using the 20mm (¾in) flat brush lightly loaded with a Hooker's green and burnt sienna mix.

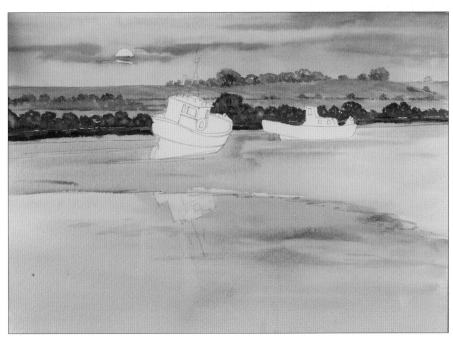

17 Wet the estuary area, being careful to avoid the boats, then use yellow ochre mixed with a touch of raw umber to paint the estuary. Add in pure raw umber wet-into-wet with broad horizontal strokes.

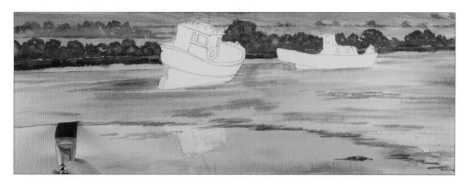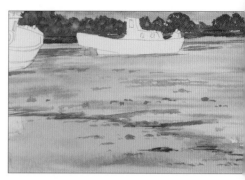

18 Strengthen the colour across the estuary, paying particular attention to the areas around the boats and on the right-hand side. While the paint is still wet, paint the water's edge with a fairly strong mix of cobalt blue and light red. Clean the 20mm (¾in) flat brush and use it to draw the wet paint at the water's edge back into the marsh.

19 Change to the size 8 round brush and use the same mix to suggest a few foreground hillocks on the estuary.

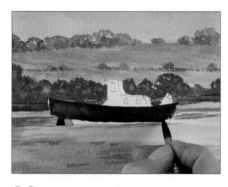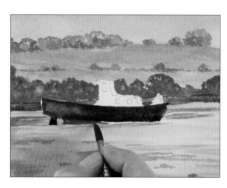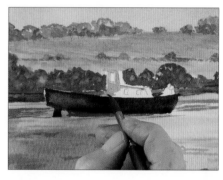

20 Mix French ultramarine with burnt sienna to make a black mix. Dilute it a little and use the size 8 round brush to block in the hull of the right-hand boat.

21 Add light red underneath, allowing the black mix to bleed into it slightly.

22 Paint the wheelhouse with a very dilute mix of cobalt blue with a touch of light red.

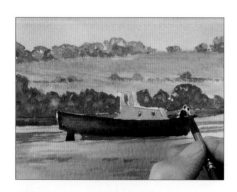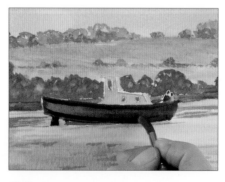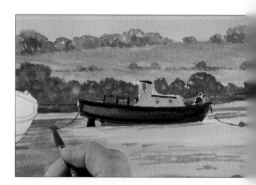

23 Paint the windows and passengers using light red and dilute black mix. Leave a white highlight around them.

24 Strengthen the hull with strokes of the black mix, then soften with a clean damp brush.

25 Add a mooring rope and details with the black mix. Mix cadmium red with a touch of yellow ochre for the buoys.

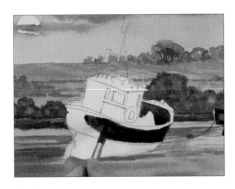

26 Use the black mix to paint the inside of the left-hand boat and the hull as shown. Use a more dilute mix wet-into-wet to show the areas of highlights.

27 Add light red wet-into-wet on the left to warm the hull.

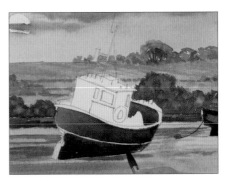

28 Use a strong mix of cobalt blue and burnt sienna to paint the lower hull, leaving a thin white border between it and the main hull.

29 Make a very strong shadow mix of cobalt blue, burnt sienna and alizarin crimson. Use this virtually undiluted to paint details on the wheelhouse roof, then add water and use it to paint the aerials and roof side.

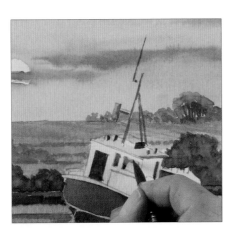

30 Use a mix of raw umber and burnt sienna for the wheelhouse door, and a cobalt blue and light red mix for the windows.

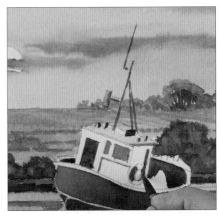

31 Use the shadow mix to paint the hull area on the left, and cadmium red for the lifebelt.

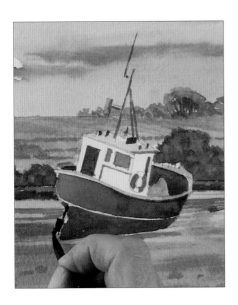

32 Add the red point on the roof with cadmium red, colour the tarpaulin with yellow ochre, then use the black mix to shade the rudder.

33 Use a cobalt blue and light red mix to shade the boat, paying attention to the side of the wheelhouse, underneath the roof and the small details.

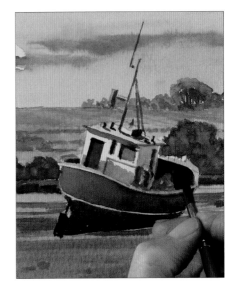

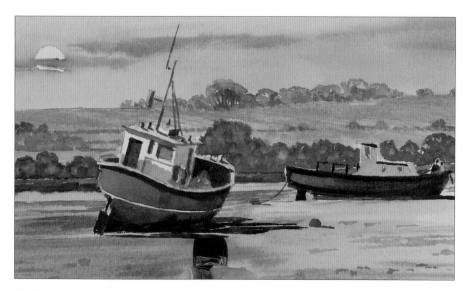

34 Use cadmium red with the size 8 round brush to paint the mooring buoy, softening it with a damp brush for the highlight. Use the shadow mix with the edge of the 20mm (¾in) flat brush to paint the shadow of the boat and the buoy with broad horizontal strokes.

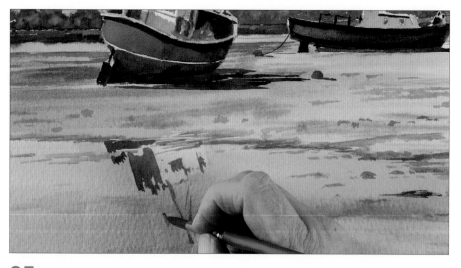

35 Use the size 8 round brush to paint the reflection of the left-hand boat with a strong shadow mix combined with a touch of light red.

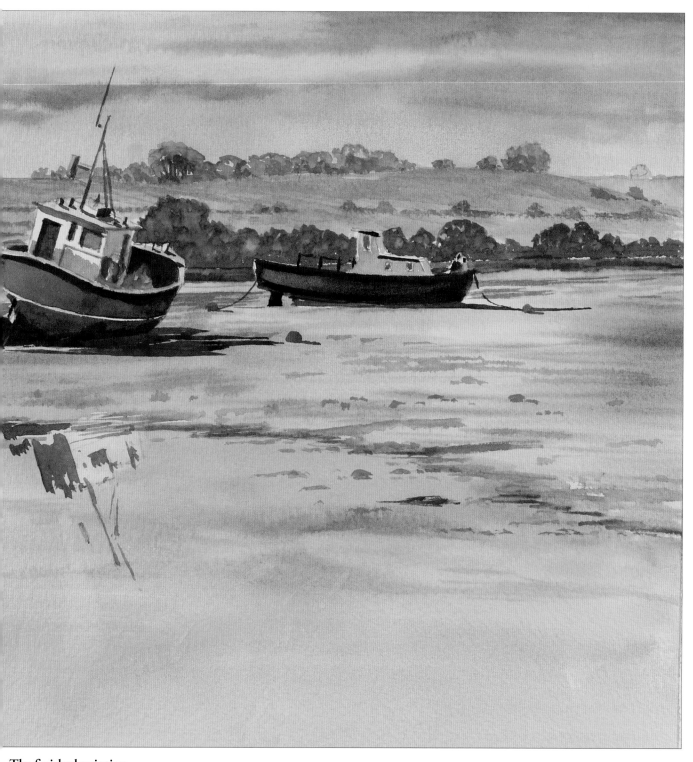

The finished painting

This view is near my home, and it never fails to inspire me.

St Ives

St Ives is a very popular holiday destination for millions of people, and you can easily see why. In this painting, a lovely jumble of buildings complement the boats beautifully.

You will need

500 x 325mm (19¾ x 12¾in) rough finish 300gsm (140lb) watercolour paper

Colours: French ultramarine, cadmium yellow, light red, yellow ochre, raw umber, burnt sienna, Hooker's green, alizarin crimson, cobalt blue and cadmium red

Brushes: 38mm (1½in) flat, 20mm (¾in) flat, size 8 round and size 3 rigger

Masking fluid and soap

Masking tape

1 Transfer the image to the watercolour paper and secure with masking tape. Apply masking fluid to the masts with the size 3 rigger. Use the 38mm (1½in) wash brush to wet the sky above the roofline with clean water, and apply French ultramarine from the top down. Clean the brush and use it to lift away any beads that form.

Tip

Remember to draw the rigger over wet soap before applying the masking fluid. This will save your brush from being damaged by the masking fluid as it dries. Rinse out the brush quickly once the fluid is applied.

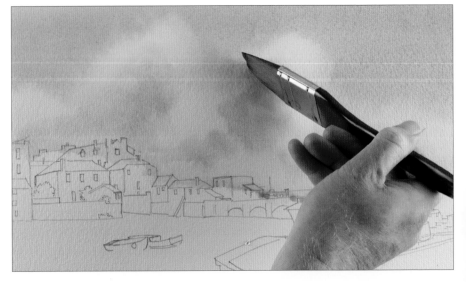

2 Wash and remove the excess water from the brush, then use it to lift out clouds. Add a touch of light red to French ultramarine, and use this to add shading to the clouds. Finish the clouds with a touch of dilute yellow ochre added wet-into-wet to vary the colour. Use the 20mm (¾in) flat brush to lift out any paint on the buildings and horizon and allow the painting to dry.

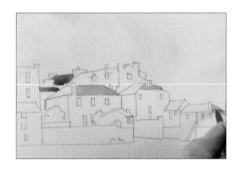

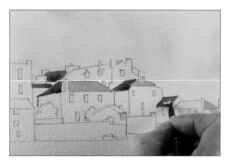

Tip
Be careful to leave a tiny sliver of dry white paper between each section of rooftop to avoid them bleeding together, and to keep them crisp.

3 Use raw umber with the size 8 round brush to paint in the rooftops in the background. As you advance, use dilute burnt sienna to paint lighter rooftops on the right-hand sides of the buildings.

4 Change back to raw umber to paint the shaded parts of the roofs on the left.

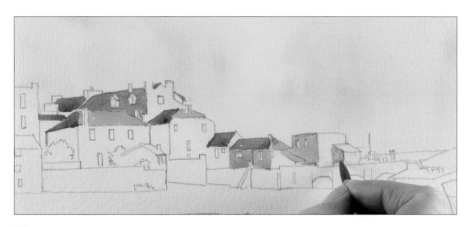

5 Mix yellow ochre and raw umber to paint the shaded sides of the buildings on the right.

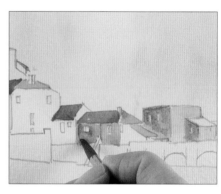

6 Use a more dilute mix to paint the highlighted sides, then add raw umber to the wet (shaded) sides to add texture.

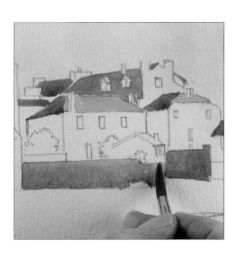

7 Still using the size 8 round brush, use raw umber and burnt sienna for the wall in front of the buildings. Add yellow ochre to the mix for the left-hand side of the wall, then lift a little out on the right as shown.

8 Add a touch of French ultramarine to the mix and block in the building on the left. As with the other buildings, paint carefully around the window areas.

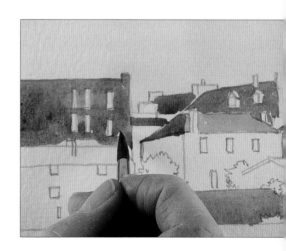

35

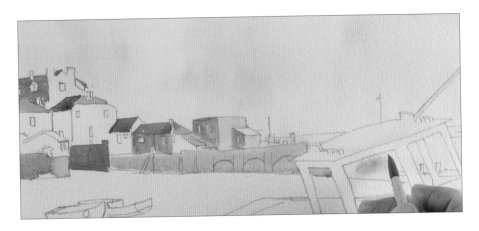

9 Wet the arched area and the background on the right, including the areas seen through the cabin of the boat. Carefully drop in yellow ochre to paint the areas.

10 Drop raw umber in wet-into-wet, then work some light red into the area to add interest and texture.

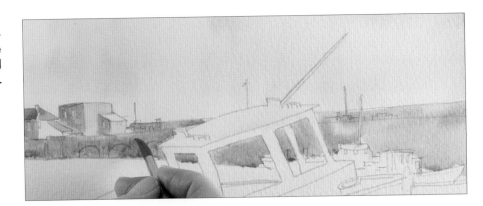

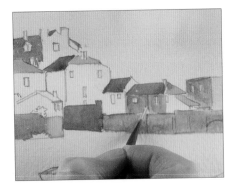

11 Clean your size 8 round brush and carefully use the tip to lift out the buttress on the wall. Allow the painting to dry.

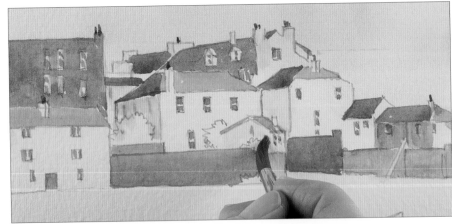

12 Paint the remaining buildings on the left with the same colours, then paint all of the windows with a mix of French ultramarine with a touch of light red. Touch in the door on the left with Hooker's green.

Tip

When painting the windows, vary the style on different buildings to make the town look more varied and realistic. Try two boxes separated by a sliver of white paper.

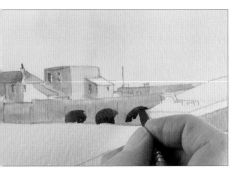 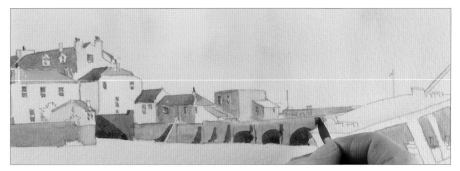

13 Make a shadow mix from French ultramarine, alizarin crimson and burnt sienna, and use it with the size 8 round brush to paint the shaded areas under the arches.

14 Add the shadow mix over the wall as shown. Work carefully, and work out where the shadows would fall in real life.

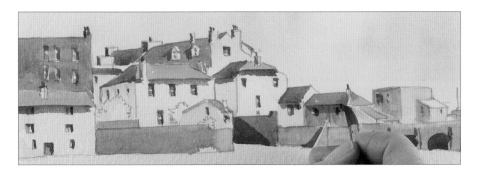

15 Recess some of the windows by edging the top and right-hand sides with the shadow mix, then run even lines of shadow beneath the rooftops.

16 Soften the shadows slightly with a touch of clean water, then add more French ultramarine to the mix and paint the remaining shaded areas of the buildings. Use a more dilute mix to add texture and interest to the buildings and walls, then allow the painting to dry completely.

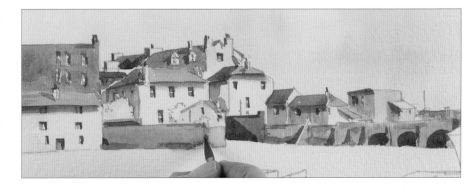

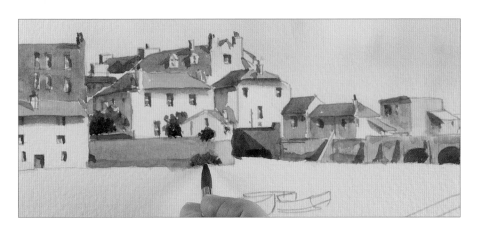

17 Use a mix of burnt sienna and Hooker's green to paint the trees. Leave a little clean paper at the top edges and use French ultramarine wet-into-wet to add shading and texture.

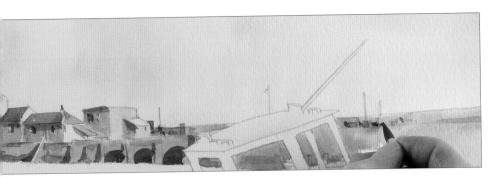

18 Still using the size 8 round brush, use French ultramarine to add some details for interest along the top of the wall. Vary the colour with touches of burnt sienna added wet-into-wet.

19 Add some dots of cadmium red just off-centre, then use light red, Hooker's green and a black mix of French ultramarine and burnt sienna to paint some figures on top of the wall on the right.

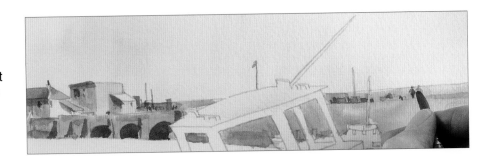

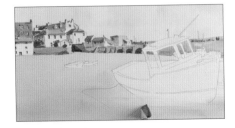

20 Wet the beach with clean water using the 20mm (¾in) flat brush, being careful to leave the boats clean and dry. Use a mix of yellow ochre, raw umber and a touch of French ultramarine to paint the beach, using a slightly less dilute mix as you advance.

21 Working wet-into-wet, add touches of light red and then yellow ochre to the sand area to add texture, interest and shading.

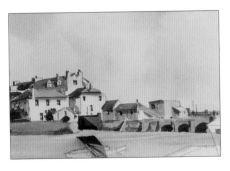

22 Add a touch of light red to French ultramarine, then apply wet-into-wet to the beach. Clean the brush, and use the edge to lift out some areas with horizontal strokes. Allow the painting to dry.

23 Use the size 8 round brush with cobalt blue to paint the left-hand boat below the buildings, lifting out a little on the right-hand side. Paint the top of the boat to the right with the same colour (inset), then use light red to paint the bottom, and a mix of cobalt blue with a touch of Hooker's green for the last boat in the group.

24 Use a mix of cadmium red and yellow ochre to paint the buoys, then make a black mix of French ultramarine and burnt sienna for the insides and details of the group of boats. Use the same black mix for the mooring ropes.

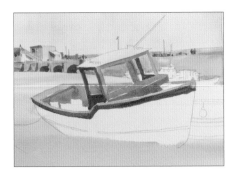

25 Make a mix of raw umber and burnt sienna, and use to block in the main parts of the main boat as shown. Use a more dilute mix to paint the areas in the light and the top of the gunwale. Leave some white spaces for cargo as shown.

26 Paint the hull of the boat and the front deck with a mix of French ultramarine and burnt sienna. Once dry, paint the bottom of the hull with light red. Do not leave a sharp, even edge: paint a curve to make the boat look embedded in the sand.

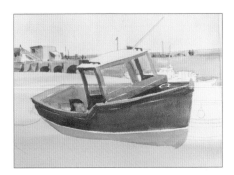

27 Paint some of the cargo with the French ultramarine and burnt sienna mix, and some with a light red and yellow ochre mix. Paint the details on the roof with the lighter mix, then lift out some of the colour from of the cargo with a little clean water.

28 Make a mix of raw umber, burnt sienna and a touch of French ultramarine. Still using the size 8 round brush, detail the inside of the boat. Allow to dry, then rub off all of the masking fluid from the painting using a clean finger (see inset).

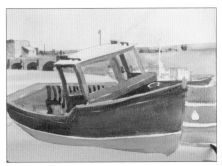

29 Use dilute cadmium red, cobalt blue and a mix of cobalt blue and Hooker's green to paint the boats on the right. Use light red to paint the bottom hull of the lowest boat as shown. Use a dilute mix of French ultramarine and burnt sienna to paint the background boats.

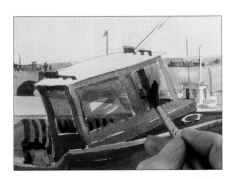

30 Paint the buoy on the red boat with a mix of cadmium yellow and cadmium red, then shade with the black mix (French ultramarine and burnt sienna). Dilute the black mix, and use it to shade and detail the background boats, and add windows and aerials to the wheelhouse.

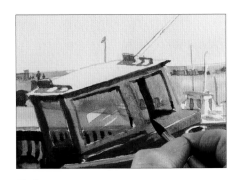

31 Make a shadow mix of French ultramarine, alizarin crimson and burnt sienna, and use this to add deep shading to the main boat.

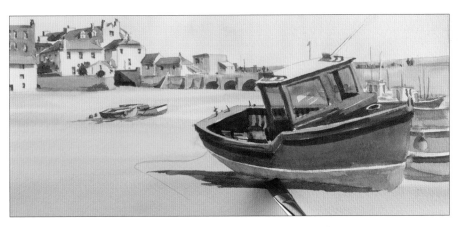

32 Using the 20mm (¾in) flat brush, add shadows to the group of small boats on the left with a dilute shadow mix. Use the same brush with broad horizontal strokes to add the shadow to the main boat, drawing the paint up and over the lower hull on the left.

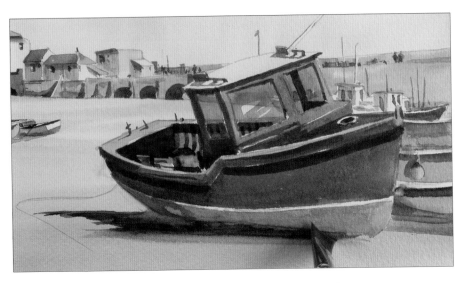

33 Soften the shadow underneath the boat with a clean damp brush.

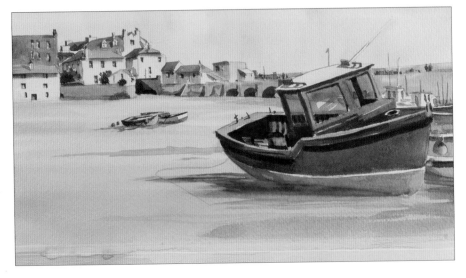

34 Add soft shadows on the beach with a very dilute shadow mix and the edge of the 20mm (¾in) flat brush. You will need to be brave, but the effect is well worth it.

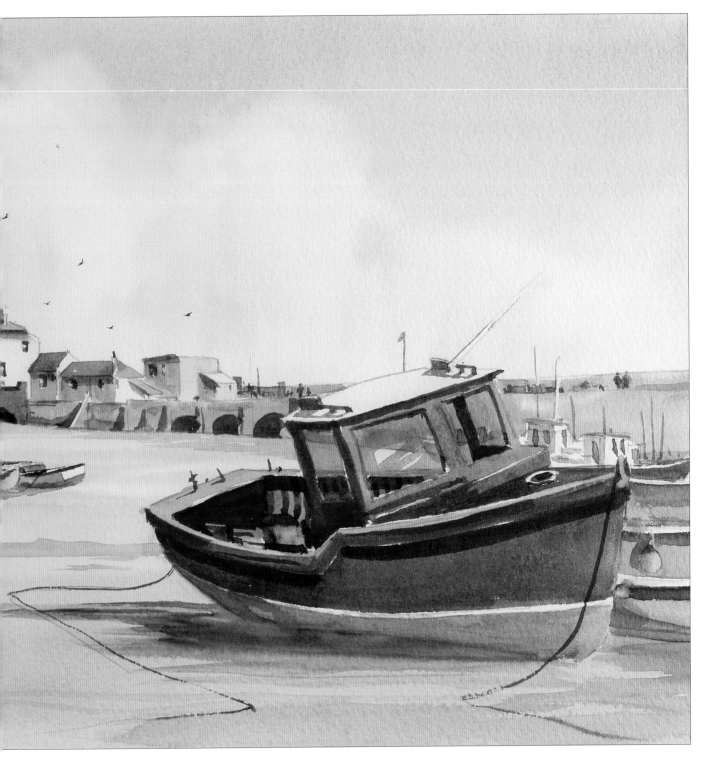

The finished painting

The masts and mooring ropes were added with the black mix and a rigger, as were the seagulls. These final details really help to finish the picture.

Norfolk Wherry

The wherry in this picture is actually called White Moth.
I spent a fabulous week running a painting holiday on
board her: enchanting!

You will need

500 x 325mm (19¾ x 12¾in)
rough finish 300gsm (140lb)
watercolour paper

Colours: yellow ochre, French
ultramarine, alizarin crimson,
light red, Hooker's green, burnt
sienna, raw umber, cadmium red
and cadmium yellow

Brushes: 38mm (1½in) flat,
20mm (¾in) flat, size 8 round and
size 3 rigger

Masking fluid and soap

Masking tape

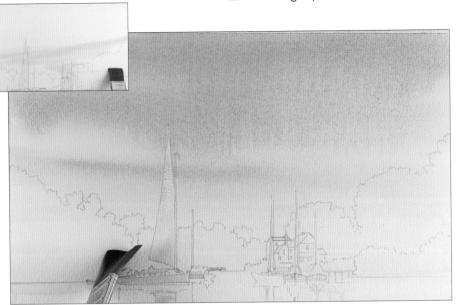

1 Transfer the picture to the
watercolour paper and secure it
with masking tape. Apply masking
fluid as shown with the rigger
brush, paying particular attention to
the broken reflection of the sails in
the water.

2 Use the 38mm (1½in) flat brush to wet the paper all the way down to
the waterline. Apply yellow ochre from the middle of the sky down to the
waterline (see inset), then apply French ultramarine wet-into-wet from the
top down. Allow it to bleed into the yellow ochre.

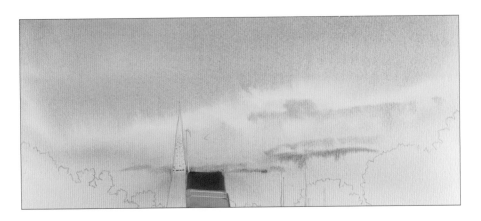

3 Rinse your brush and tap off the
excess water. Lift out clouds with
the damp brush, then add cloud
shadows with a mix of alizarin
crimson and French ultramarine.

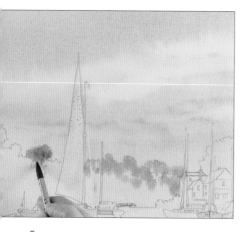

4 Mix French ultramarine with a touch of light red, and use the size 8 round brush to drop it in wet-into-wet as distant trees.

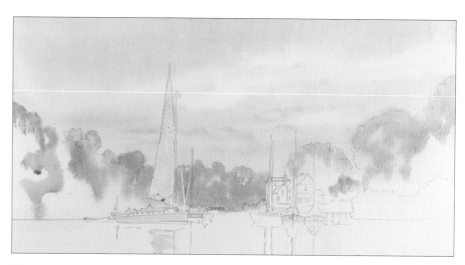

5 Still using the size 8 brush, apply yellow ochre to the upper parts of the trees in the foreground, leaving some clean white spaces.

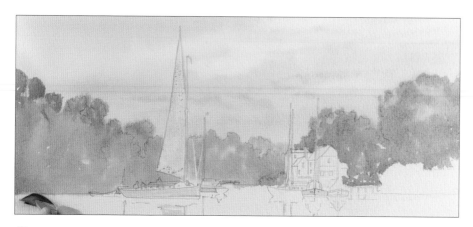

6 Apply a mix of Hooker's green and yellow ochre wet-into-wet to the trees. Work carefully around the hotel, and make sure that some clean paper and yellow ochre show through. Lift out any paint that bleeds below the waterline with a clean, damp 20mm (¾in) flat brush.

7 Dilute the Hooker's green and yellow ochre mix, then add touches to the background trees using the size 8 round brush.

8 Mix Hooker's green and burnt sienna, and use it to add shading to the green areas using quick, stippling brushstrokes. Work carefully around the hotel.

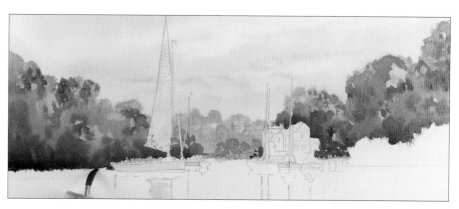

9 Continue working the Hooker's green and burnt sienna mix across the foliage, then add in touches of pure French ultramarine wet-into-wet down to the waterline for the deepest shades.

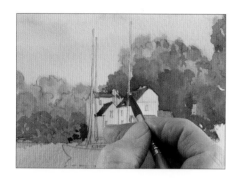

10 Use a fairly dilute mix of burnt sienna and raw umber to paint the rooftops of the hotel, using a slightly stronger mix for the left-facing sides.

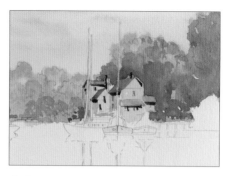

11 Paint the walls with a mix of yellow ochre and raw umber, adding more raw umber to the shaded sides. Paint the windows with a black mix of French ultramarine and burnt sienna, then use a stronger mix to paint the roof overhang and the shading on the windows.

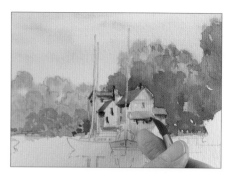

12 Dampen the size 8 round brush and use it to soften the shadows. The brush will pick up some of the paint, and you can use this to add subtle details to the hotel.

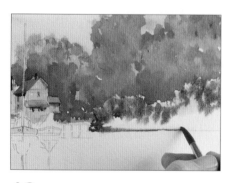

13 Wet the foreground bushes with the size 8 round brush, and paint them with a stippling action and yellow ochre. Add a mix of Hooker's green and burnt sienna wet-into-wet.

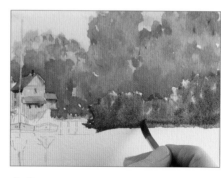

14 Add burnt sienna to warm the foliage, then French ultramarine at the base to shade it and give a feeling of volume and texture.

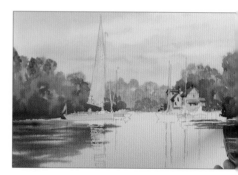

15 Use the 38mm (1½in) flat brush to wet the river. Mix Hooker's green with burnt sienna, and use the edge of the brush in a broken zig-zag motion to paint reflections of the trees on both sides as shown.

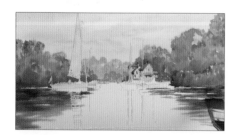

16 Mix French ultramarine with burnt sienna, and add this mix wet-into-wet with the same motion to the top part of the reflection. Allow the painting to dry.

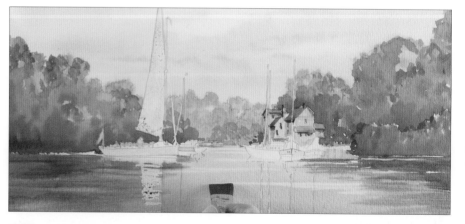

17 Wet the water area again, and use a mix of French ultramarine, Hooker's green and burnt sienna to paint the area, working carefully around the boats. Lift out some ripples with a clean 20mm (¾in) flat brush, then allow to dry completely.

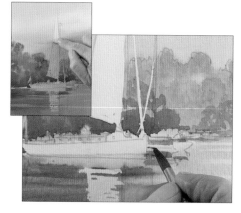

18 Carefully rub away all of the masking fluid with a clean finger (see inset), then use the size 8 round brush to paint the boat on the left of the middle-distance with a mix of raw umber and burnt sienna. Add a reflection, then paint a band of burnt sienna and French ultramarine on the waterline as shown.

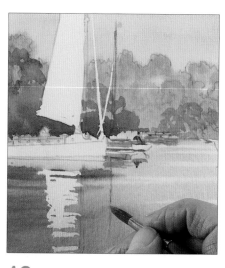

19 Use the same French ultramarine and burnt sienna mix for the central boat of the left-hand group. Mix yellow ochre and raw umber for shading and the mast and reflection.

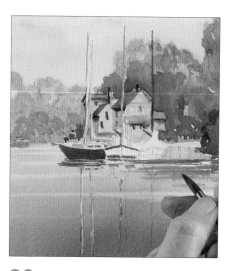

20 Detail the central boat of the right-hand group with burnt sienna and raw umber. Mix yellow ochre and raw umber for shading and the mast, then paint the right-hand boat's mast with the raw umber and burnt sienna mix.

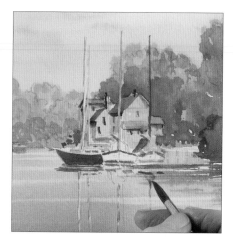

21 Detail the right-hand boat with cobalt blue and light red. Dilute the colours for highlights, and use the same colours for reflections.

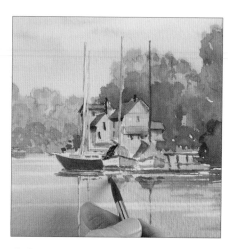

22 Use yellow ochre and burnt sienna for the central boat's cabin and for the reflection.

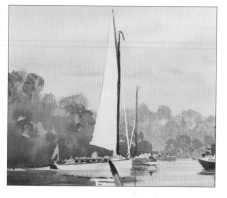

23 Paint the mast and reflection of the foreground boat with a mix of raw umber and burnt sienna. Shade this with a black mix of French ultramarine and burnt sienna down the left-hand side. Paint the pennant with cadmium red, then paint the top of the boat with a mix of raw umber and burnt sienna, working carefully round the portholes.

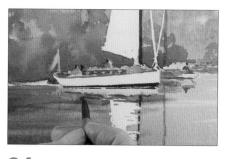

24 Use the black mix to paint the bottom of the hull and the broken reflection, then paint the figures and their reflections with cadmium red, cadmium yellow, Hooker's green and the black mix for details.

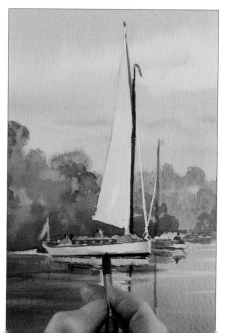

25 Use a mix of yellow ochre and raw umber with a touch of French ultramarine to paint the sail and the reflection. Leave a touch of white to signify a crease. Add shading to the boat with dilute French ultramarine, softening the shading with the tip of a clean wet brush.

45

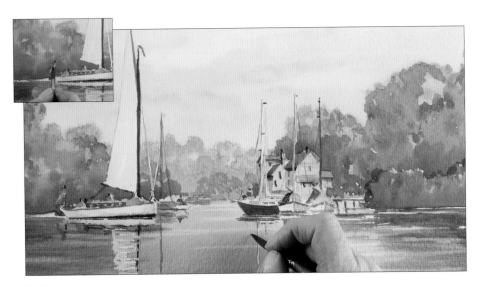

26 Paint the flagpole at the stern with the black mix, and use cadmium red for the flag (see inset), then use the tip of the size 8 round brush with a French ultramarine and burnt sienna mix to add rigging and detail to all of the masts and boats.

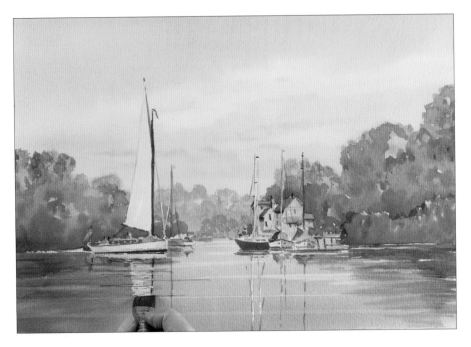

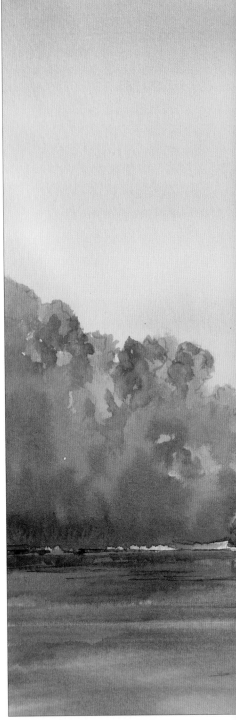

27 Still using the French ultramarine and burnt sienna mix, use the edge of the 20mm (¾in) flat brush to add broken wavelets and shading to ripples in the river.

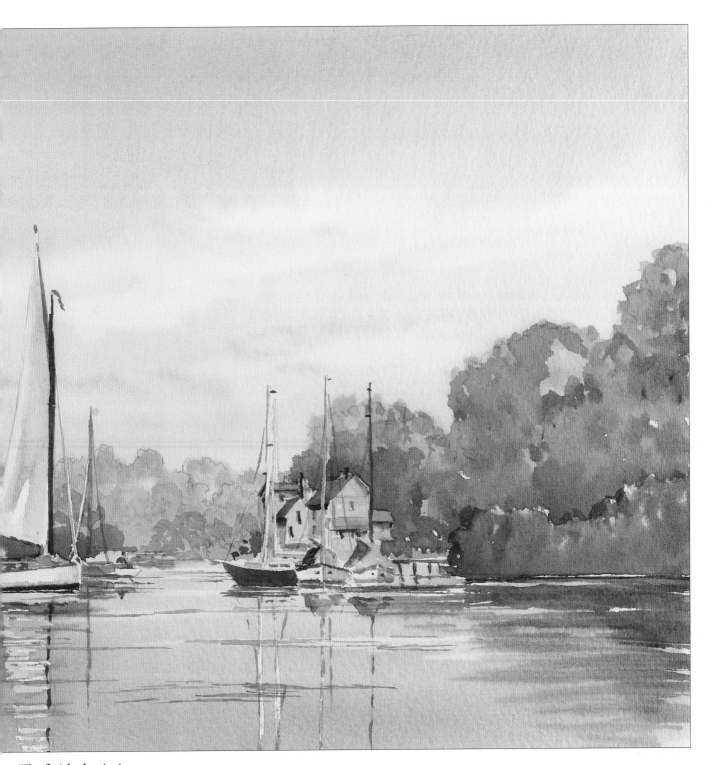

The finished painting

Some final shading was added to the sail with a dilute mix of French ultramarine and burnt sienna, and the canoe to the left of the foreground boat was added with yellow ochre.

Index

background 11, 19, 20, 22, 27, 28, 29, 35, 36, 39, 43
beach 38
bird 16, 17, 41
board 8, 18
boat 12, 13, 14, 15, 17, 20, 21, 22, 23, 24, 29, 30, 31, 32, 33, 34, 36, 38, 39, 40, 44, 45, 46, 47
brushes 7, 8
 38mm (1½in) flat 7, 10, 18, 33, 34, 42, 44
 20mm (¾in) flat 7, 10, 11, 12, 13, 14, 16, 18, 19, 23, 24, 26, 30, 32, 33, 34, 38, 40, 42, 43, 44, 46
 size 3 rigger 7, 10, 18, 22, 33, 34, 41, 42
 size 8 round 7, 10, 11, 12, 13, 14, 16, 18, 19, 20, 21, 22, 23, 26, 27, 28, 30, 32, 33, 34, 35, 36, 37, 38, 39, 42, 43, 44, 45, 46
buildings 18, 33, 34, 35, 36, 37
buoys 14, 15, 16, 30, 32, 39
bushes 28, 29, 44

cabin 13, 14, 15, 21, 22, 36, 45
clouds 18, 26, 27, 42

detail 12, 13, 14, 15, 16, 20, 22, 31, 38, 39, 41, 44, 46

estuary 28, 29, 30

figures 38, 45
foliage 19, 28, 43, 44
foreground 11, 14, 19, 23, 24, 29, 30, 43, 44, 45, 47

gunwale 15, 39

hedgerows 28, 29
highlights 11, 15, 22, 30, 31, 32, 35, 45
hills 11, 27, 28, 29
horizon 10, 18, 20
hotel 43, 44
hull 15, 22, 30, 31, 39, 45

lifting out 10, 14, 18, 21, 35, 38, 42, 44

masking fluid 7, 8, 12, 34, 42, 45
masking tape 8, 10, 18, 26, 34, 42
mast 20, 21, 22, 23, 41, 45, 46
mooring post 15, 24

paints 6, 8
paper 7, 8, 9, 10, 18, 26, 33, 34, 42
pencil 8, 9
pennant 21, 22, 45

pier 11, 12
pub 19, 20

reflection 13, 14, 21, 22, 23, 24, 27, 32, 42, 44, 45
rigging 12, 13, 21, 46
ripples 14, 23, 46
rooftops 34, 35, 37, 44
rope 14, 30, 38, 41

sail 21, 22, 42, 47
sand 14, 16, 27, 38
shading 12, 13, 15, 16, 18, 19, 20, 21, 23, 29, 35, 37, 38, 39, 43, 44, 45, 47
sky 6, 10, 16, 26, 27, 42
soap 8, 34, 42
stippling 19, 28, 43, 44

texture 12, 14, 19, 21, 35, 36, 37, 38
tracing 2, 9, 18, 26
trees 19, 20, 27, 28, 43, 44

waterline 21, 42, 43, 45
wavelet 23, 46
wet-into-wet 12, 13, 14, 15, 18, 19, 21, 29, 31, 37, 38, 43, 44
wheelhouse 30, 31, 39

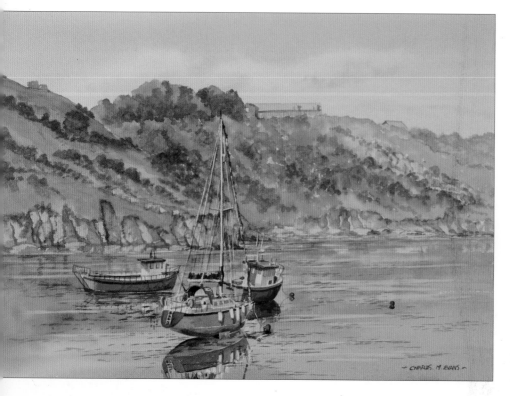

Little Welsh Inlet
500 x 325mm (19¾ x 12¾in)

DOLLY PEG FAIRIES & PRINCESSES
Craft Book

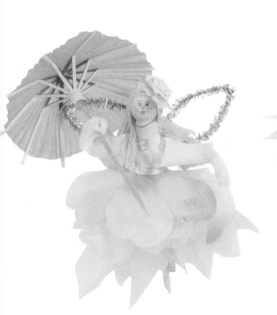
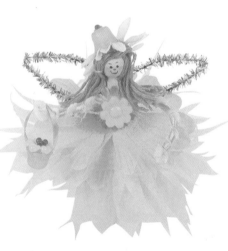

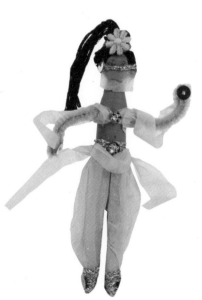

TOP THAT™

Licensed exclusively to Top That Publishing Ltd
Tide Mill Way, Woodbridge, Suffolk, IP12 1AP, UK
www.topthatpublishing.com
Copyright © 2015 Tide Mill Media
0 2 4 6 8 9 7 5 3 1
Manufactured in China

Fairies and Princesses

Get ready to transform ordinary wooden dolly pegs into a collection of pretty fairies and princesses!

It's easy!

First, be inspired by the photograph of the fairytale character you want to make. Then, just follow the simple step-by-step instructions to create her for yourself!

Items you'll need

Buy your number one fairy and princess component – dolly pegs – from craft and hobby shops, or online. You'll also need a selection of coloured tissue paper, fuzzy sticks and felt-tip pens or crayons as part of your kit, plus some other items. Make sure you have glue and scissors at hand for all your projects.

Check out the list at the beginning of each project and gather everything together before you start. That means you'll be ready to get making straight away!

Tissue paper and decorations

Every project uses a piece of tissue paper measuring 30 x 30 cm, so cut this out in the colour you need before you begin.

These lovely peg dolls need plenty of decoration, so start a collection of pretty bits and pieces that you can use anytime you want. Beads, sequins, buttons, scraps of ribbon and anything else sparkly will be useful!

Be inspired!

The step-by-step instructions are a guide to making each fairy or princess. If you don't have all the items, or you want to dress your characters differently, don't be afraid to experiment with the designs and materials. You can adapt each look to make your own versions of these perfectly pretty fairies and princesses.

Top Tips

Follow these top tips for perfect princesses and fairies every time!

Keep both hands free to decorate your peg dolls by standing them in a piece of sticky putty.

If you run out of tissue paper, use fabric scraps, coloured paper or even tinfoil.

Keep any offcuts to make your characters' hats, shoes and accessories. You can even use dried leaves or flowers from the garden!

Give each fairy and princess a different expression. Happy, sad, excited, surprised … you decide!

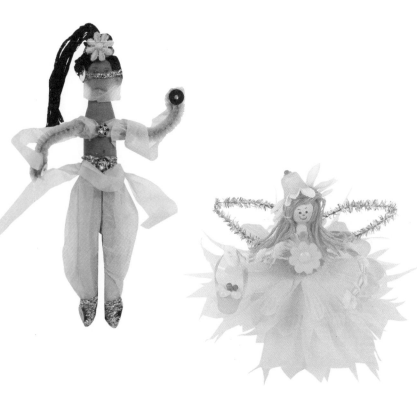

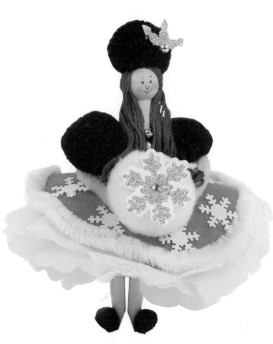

Warning:
Fuzzy sticks and scissors have sharp points. Use under direct adult supervision.

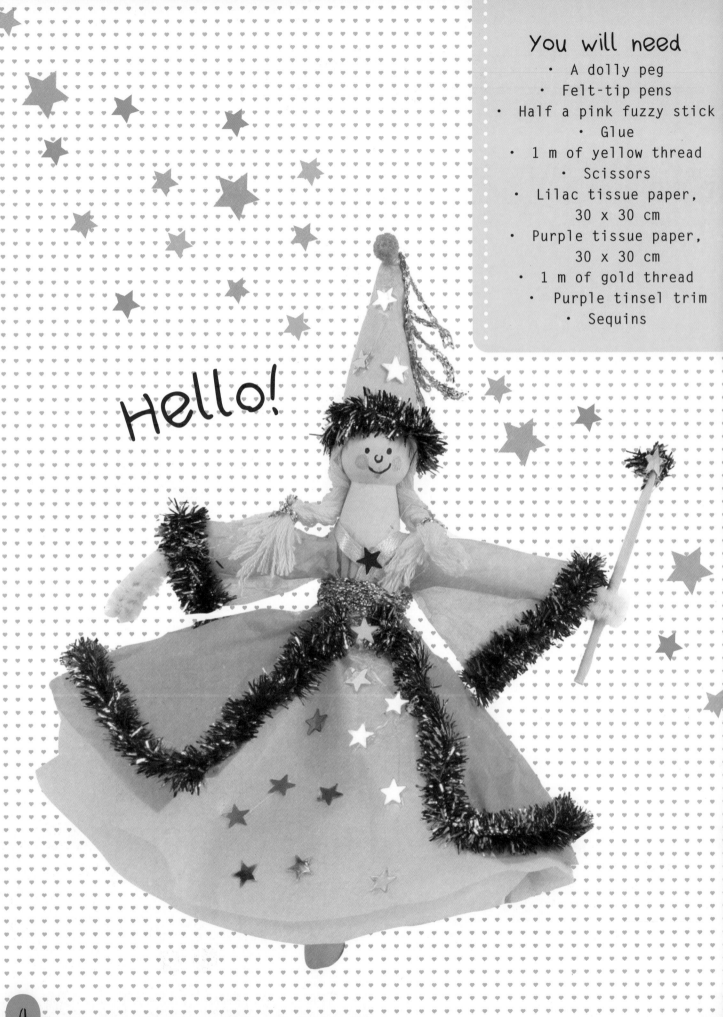

Hello!

Medieval Princess

1 Use the felt-tip pens to draw on the dolly peg's features.

If you do it wrong, paint over your mistake and start again!

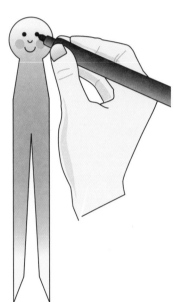

2 Take half a pink fuzzy stick. Ask an adult to turn over the ends to make the princess's arms and hands.

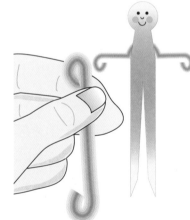

Stick it to the back of the dolly peg and leave it to dry.

3 Take the yellow thread. Fold it over and repeat until you have the desired length of hair, then stick to the dolly peg's head.

Ask an adult to trim the ends with scissors to neaten when dry.

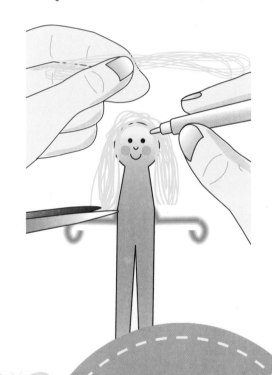

TOP TIP

Try separating the hair into bunches, tying the ends with a piece of gold thread. Or why not plait your princess's lovely long locks?

4 Take a sheet of lilac tissue paper. Ask a grown-up to cut it into four equal squares, as shown. Take one square and fold it into a triangle. Fold it again and then once more, as shown. Ask a grown-up to snip off the right-hand point, then to cut out the shape shown. Unfold the tissue to reveal a layer of the princess's skirt. Repeat with another lilac tissue square and then with two purple tissue squares.

5 Ask a grown-up to cut out a piece from one of the purple rings, as shown.

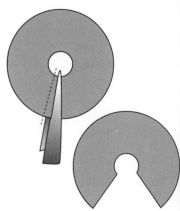

6 Spread a small ring of glue around your dolly's waist, and then stick the lilac tissue rings in place to make the underskirt. Stick the purple piece of tissue paper on top, leaving a gap, as shown.

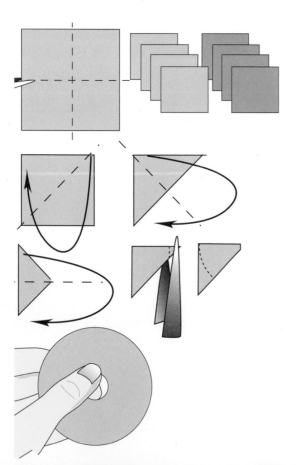

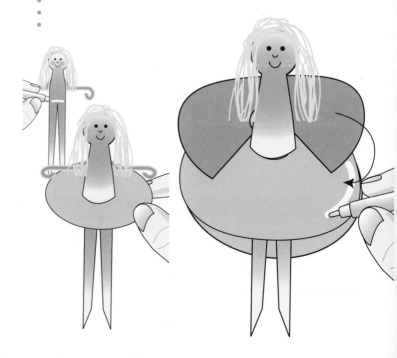

7 Fold a square of lilac tissue paper in half. Ask a grown-up to cut it according to the pattern below. Unfold it and slip it over the princess's head. Stick the sides together to make her top.

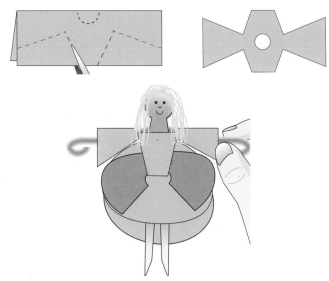

8 Take the ring of purple tissue left over from step 5. Ask a grown-up to cut a slit from the outside edge to the centre. Make the hat by overlapping the edges and sticking them in place. Trim into a small cone shape.

9 Stick the hat on to the dolly's head, then decorate her outfit. Use gold thread around her waist and on the top of her hat, and purple tinsel trim around her skirt. Use sequins to add sparkle, and any offcuts of tinsel trim for her shoes.

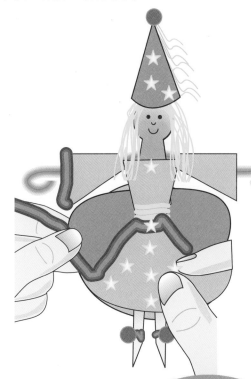

TOP TIP
Make your princess a wand from a cocktail stick and a sequin.

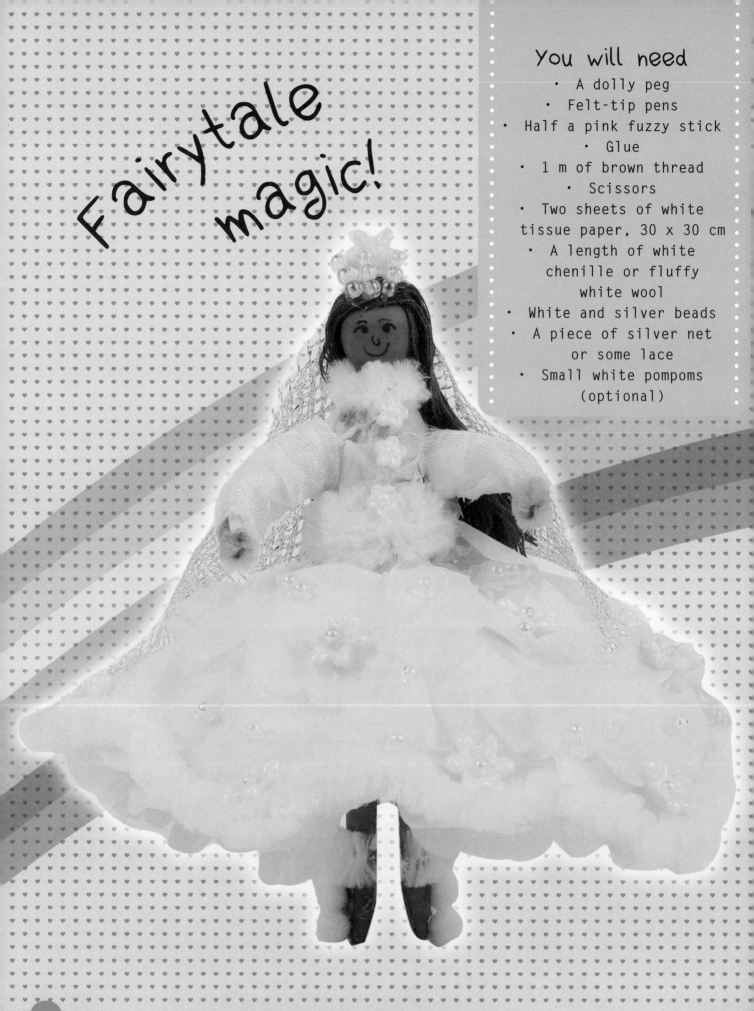

Fairytale magic!

Fairytale Princess

1 Use the felt-tip pens to draw the princess's features. (You could try her expression out on paper first.)

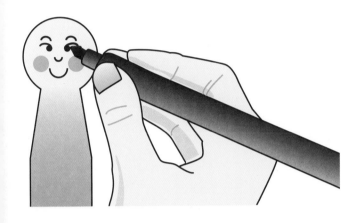

2 Take half a pink fuzzy stick. Ask a grown-up to turn over the ends to make the princess's arms and hands. Stick it to the back of the dolly peg and leave it to dry.

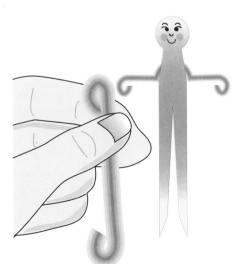

3 Take the brown thread. Fold it over and repeat until you have the desired length of hair, then stick to the dolly peg's head. Ask a grown-up to trim the ends with scissors to neaten when dry.

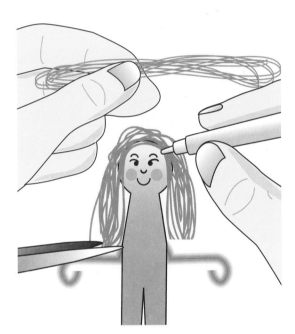

4 Take two sheets of white tissue paper. Ask a grown-up to cut each into four equal squares, as shown.

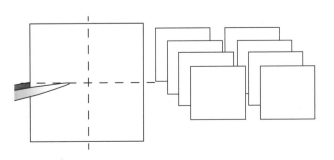

5 Take one square of tissue paper and fold it into a triangle. Fold it again and then once more, as shown. Ask a grown-up to snip off the right-hand point, then to cut out the wavy pattern, as shown. Unfold the tissue to reveal a layer of the princess's underskirt. Repeat with two more tissue squares.

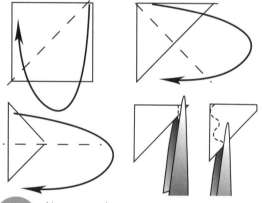

6 Now ask a grown-up to turn two tissue squares into the smaller top layers of the princess's skirt by cutting further up the folded triangle.

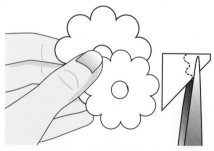

7 Spread a small ring of glue around your dolly's waist. Starting with the smaller pieces of tissue, stick the layers in place until you have finished her skirt.

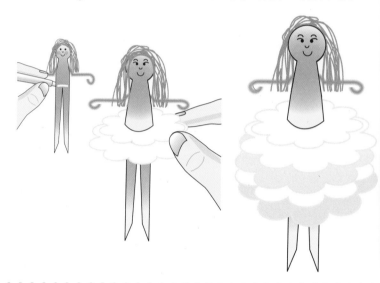

8 Fold a square of tissue paper in half. Ask a grown-up to cut it according to the pattern below. Unfold it and slip it over the princess's head. Glue the sides together to make her top.

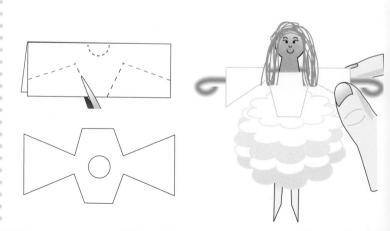

9 Glue one end of the chenille or wool to the back of the princess. Wind it around her waist, then trim off any excess and stick down the end. Do the same around her neck.

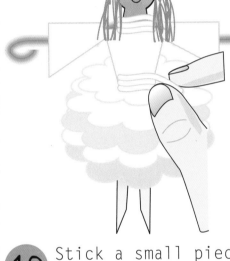

10 Stick a small piece of white chenille or wool around each foot to make your princess's shoes. You could add pompoms, as shown.

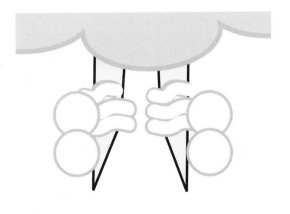

11 Trim the edge of the princess's skirt with white chenille or wool, then decorate her outfit with beads. We made her a hat from a flower bead and a tiara from three rows of seed beads.

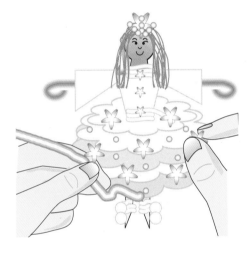

12 Use a small piece of silver net or lace to make her train. Glue it in place at the back of her head.

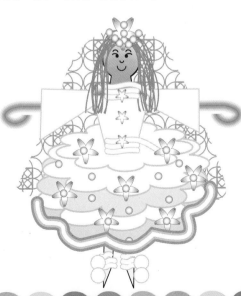

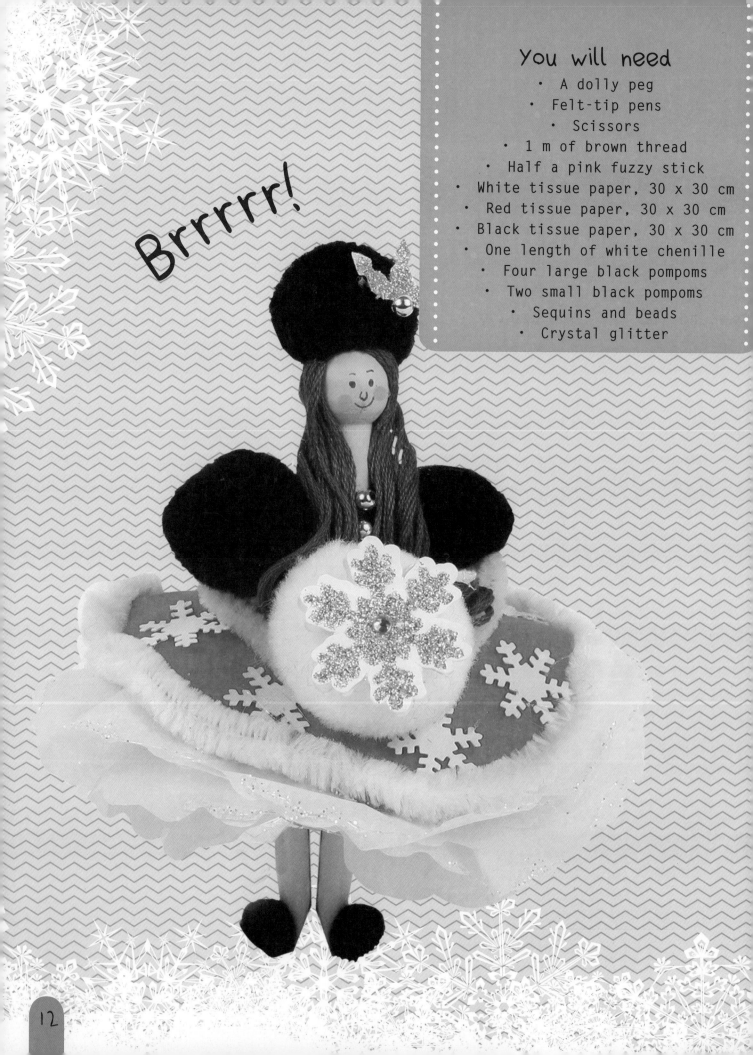

Brrrrr!

Russian Princess

1 Use the felt-tip pens to draw the princess's features. You could try a different expression from other characters you have made.

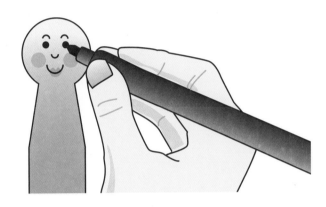

2 Take half a pink fuzzy stick. Ask a grown-up to turn over the ends to make the princess's arms and hands. Stick it to the back of the dolly peg.

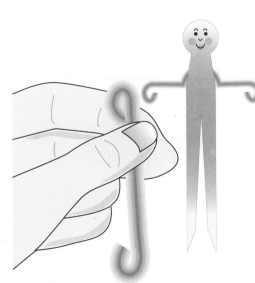

3 Take the brown thread. Fold it over and repeat until you have the desired length of hair, then stick to the dolly peg's head. Ask a grown-up to trim the ends with scissors to neaten when dry.

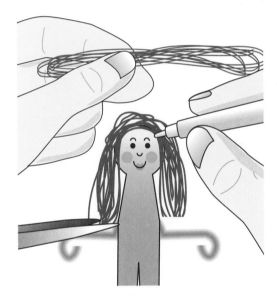

4 Take a sheet of white tissue paper. Ask a grown-up to cut it into four equal squares, as shown.

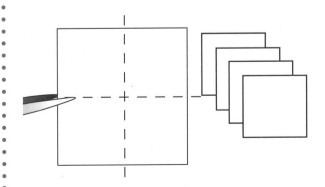

5 Take a square of white tissue paper and fold it into a triangle. Fold it again, then once more, as shown. Ask a grown-up to snip off the right-hand point, then to cut out the wavy pattern, as shown. Unfold the tissue to reveal a layer of the princess's skirt. Repeat with two other white tissue squares.

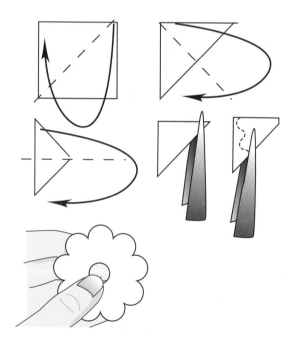

7 Unfold the red tissue paper to reveal a ring.

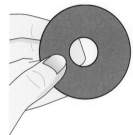

Then spread a thin line of glue around your princess's waist, ready to add her clothes.

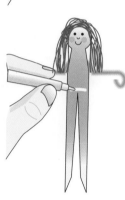

8 Starting with the red ring, layer the tissue paper to make your princess's skirt.

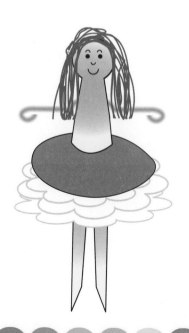

6 Take a piece of red tissue paper. Follow steps 4 and 5, folding just one red tissue square, but this time cutting a semicircle.

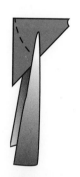

9 Take the black tissue paper and follow step 4. Fold one square in half, as shown, then ask a grown-up to cut it according to the pattern below. Unfold it and slip it over the princess's head. Glue the sides together to make her top.

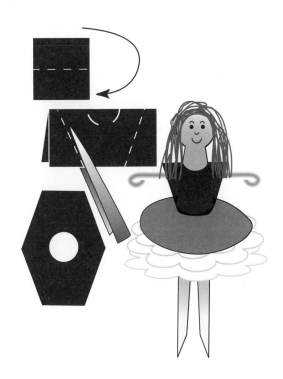

10 Take three large black pompoms. Glue one on the top of each arm for sleeves and the other on top of her head for a hat. Glue another large pompom to her front for a muffler, and add two small pompoms for shoes.

11 Add a frosty sparkle to your princess's white skirt by decorating the edges with glitter. It's a good idea to do this over a sheet of old newspaper.

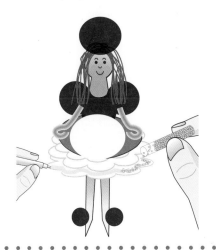

12 Glue a piece of white chenille around the edge of the red tissue and decorate your princess's outfit with beads and sequins.

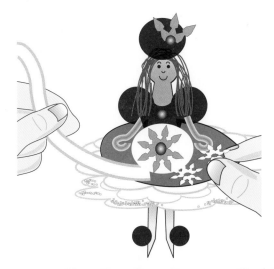

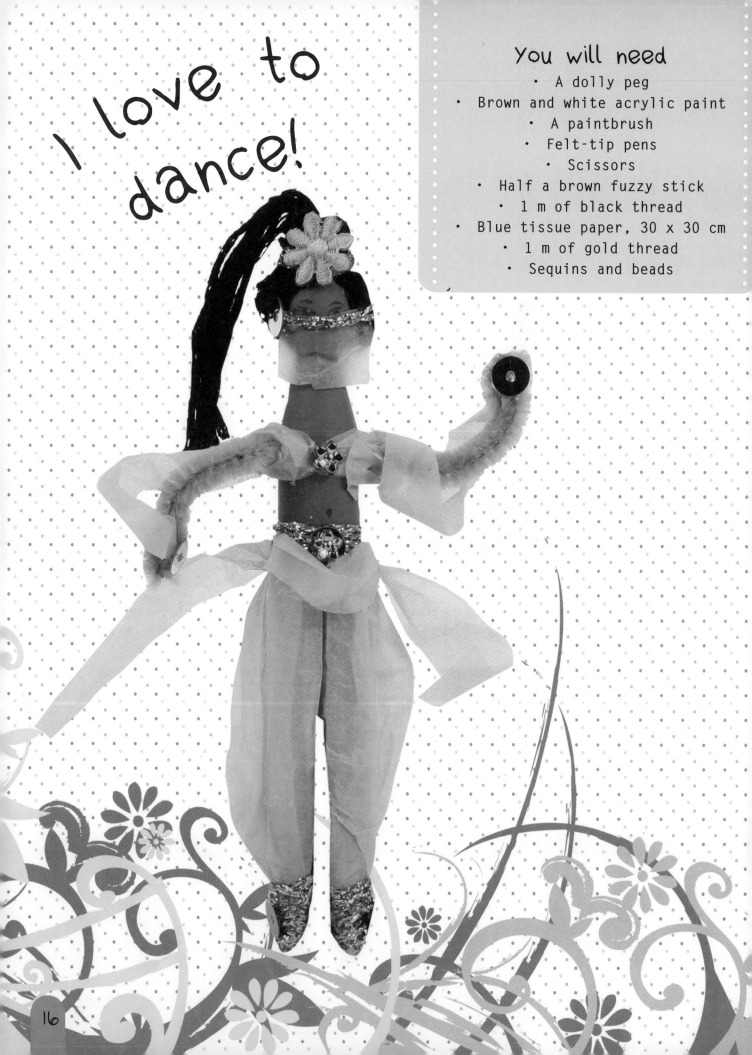

I love to dance!

You will need

- A dolly peg
- Brown and white acrylic paint
- A paintbrush
- Felt-tip pens
- Scissors
- Half a brown fuzzy stick
- 1 m of black thread
- Blue tissue paper, 30 x 30 cm
- 1 m of gold thread
- Sequins and beads

Arabian Princess

1 Mix brown and white paint to make a light brown, then paint the dolly peg and leave to dry. Use the felt-tip pens to draw her features.

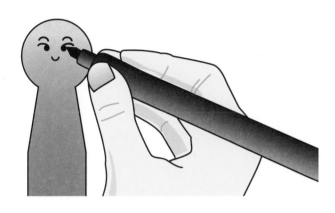

2 Take half a brown fuzzy stick. Ask a grown-up to turn over the ends to make the princess's arms and hands. Stick it to the back of the dolly peg.

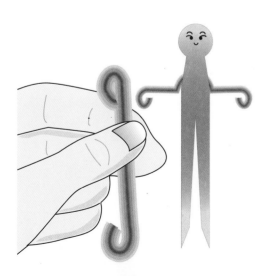

3 Take the black thread. Fold it over and repeat until you have the desired length of hair, tie a knot to make a ponytail, then stick the hair to the dolly peg's head. Ask a grown-up to trim the ends to neaten when dry.

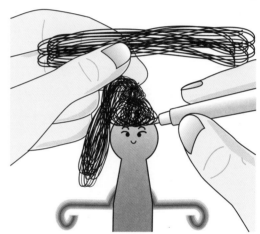

4 Take a sheet of blue tissue paper. Ask a grown-up to cut it into four equal squares, as shown.

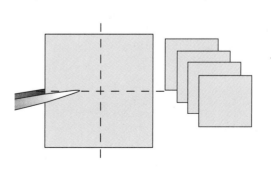

5 Take one square of tissue and ask a grown-up to cut it in half.

Twist one half in the centre to create the bikini top.

Cut the other half into two strips and put to one side.

Take another square of tissue and cut out a small rectangle to make a veil.

Pleat a third square of tissue, and then ask a grown-up to cut it in half to make pantaloons.

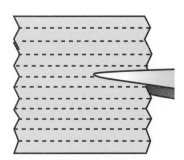

6 Spread a thin line of glue down the outside of one of the dolly peg's legs and waist, as shown. Take one of the pleated rectangles and stick it in place, gathering the tissue around the waist and ankle. Repeat with the other piece of pleated tissue.

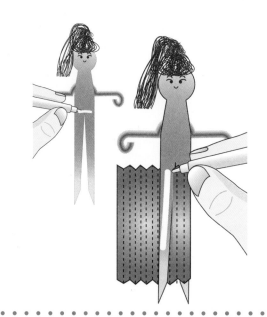

7 Draw your dolly's belly button above the waistline of her pantaloons.

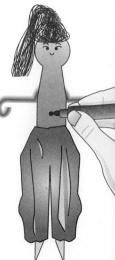

8 Glue the bikini - the twisted piece of tissue paper - in place, ensuring the ends are stuck at the back. Stick the veil - the small rectangular piece of tissue paper - across the dolly's face.

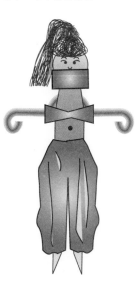

9 Take the gold thread and glue one end to the back of the dolly's waist. Carefully wind it around her waist and stick down the end. Stick a small length of gold thread around the top of her veil and another around the knot of her ponytail. Wind some around her feet to make her shoes and glue down the ends.

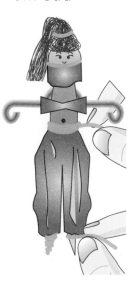

10 Take the two strips of tissue. Stick the end of one piece to one of the dolly's hands. Take it across her back and stick the other end to her other hand. Twist the other strip either side of the centre and stick to the hips at the gold waistband.

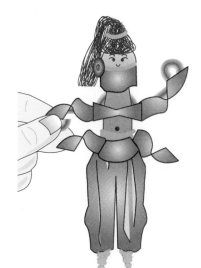

11 Decorate your princess's outfit by gluing sequins to either side of her veil. Glue a sequin to each hand and each shoe. Glue beads to her waistband and her bikini top, and add decoration to her headband.

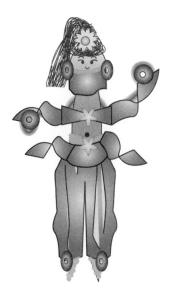

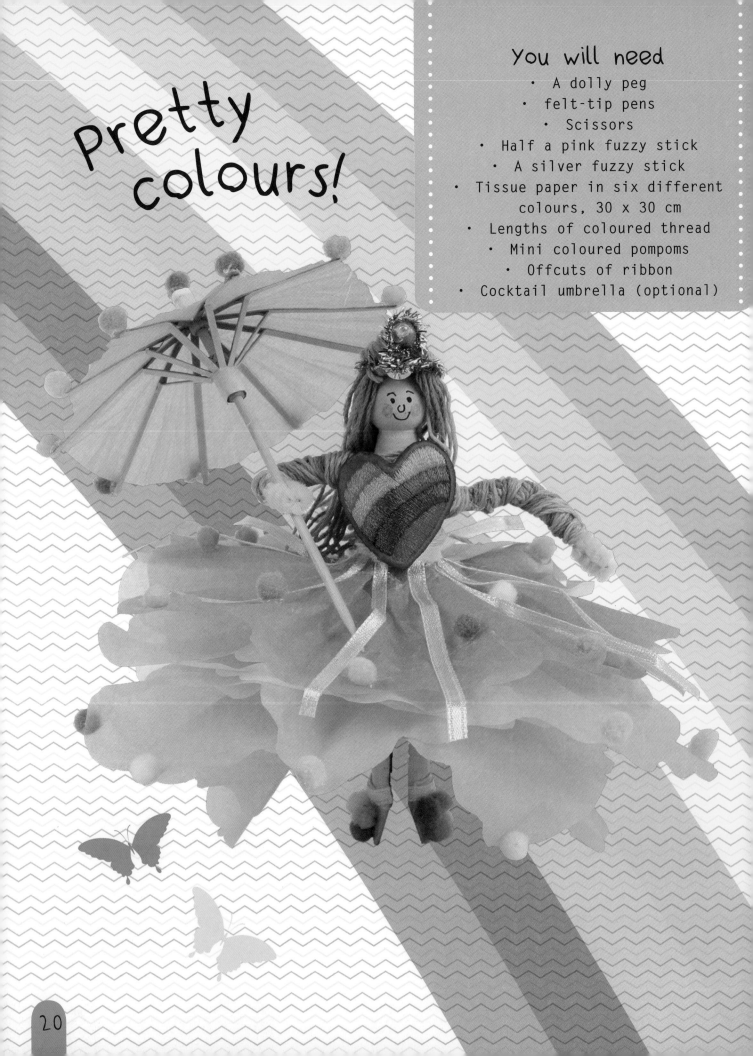

pretty colours!

You will need
- A dolly peg
- felt-tip pens
- Scissors
- Half a pink fuzzy stick
- A silver fuzzy stick
- Tissue paper in six different colours, 30 x 30 cm
- Lengths of coloured thread
- Mini coloured pompoms
- Offcuts of ribbon
- Cocktail umbrella (optional)

Rainbow Princess

1 Use felt-tip pens to draw the princess's features. (She's bound to be happy with a name like Rainbow Princess!)

2 Take half a pink fuzzy stick. Ask a grown-up to turn over the ends to make the princess's arms and hands. Stick it to the back of the dolly peg and leave it to dry.

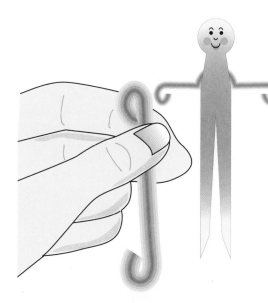

3 Take several 20 cm lengths of coloured thread and glue them to the dolly peg's head. Ask a grown-up to trim the ends with scissors to neaten when dry.

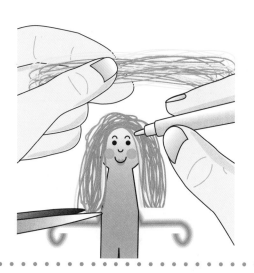

4 Take tissue paper in six colours. Ask an adult to cut each sheet into four squares, as shown. You will need one small square of each colour. (Keep the rest of the small squares for other projects.)

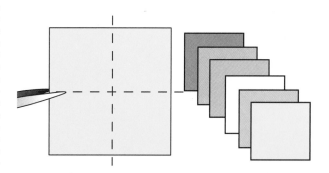

5 Take a square of tissue paper and fold it into a triangle. Fold it again, then once more, as shown. Ask a grown-up to snip off the right-hand point, then to cut out the wavy pattern, as shown. Unfold the tissue to reveal a layer of the princess's skirt. Repeat with four other tissue squares, keeping the last one back to use in step 7.

6 Spread a thin line of glue around your princess's waist, then layer the tissue paper rings to make her colourful skirt.

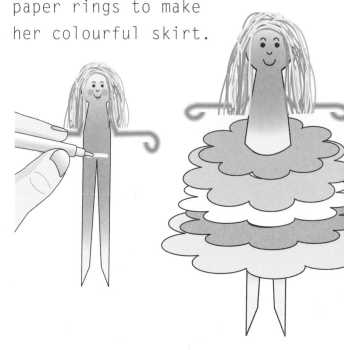

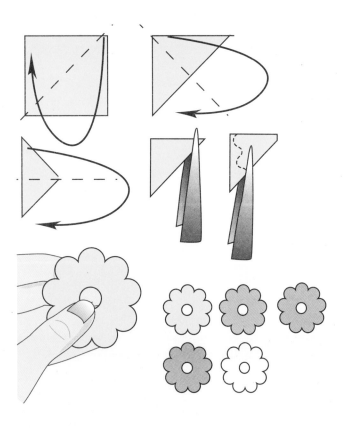

7 Fold the remaining square of tissue in half. Ask a grown-up to cut it according to the pattern shown to create the princess's top.

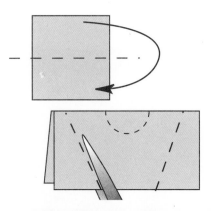

8 Unfold the top and slip it over the princess's head. Glue the sides together to finish.

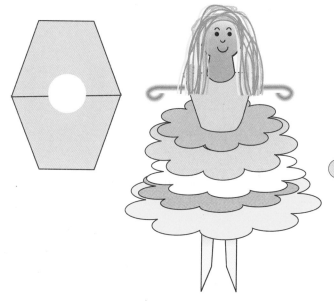

9 Ask an adult to bend a small piece of silver fuzzy stick into a loop to make your princess's tiara. Glue mini pompoms to her feet to make her shoes.

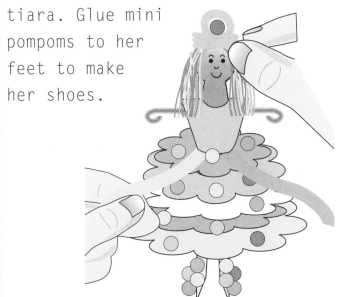

10 Use offcuts of ribbon and pompoms or anything else you like to decorate your princess's rainbow-coloured outfit.

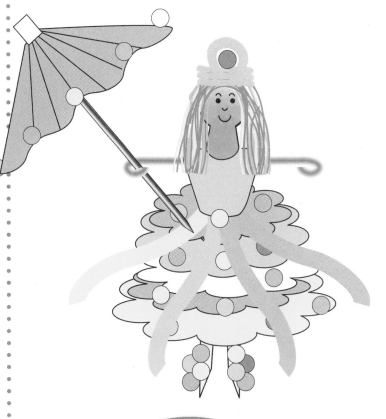

TOP TIP
Decorate a cocktail umbrella with mini pompoms to make a pretty parasol for your princess.

I love spring!

you will need
- A dolly peg
- Felt-tip pens
- Half a pink fuzzy stick
- Scissors
- Yellow tissue paper, 30 x 30 cm
- A length of yellow ribbon
- 1 m of orange thread
- Two large decorative flowers
- Three small decorative flowers
- Beads
- One silver fuzzy stick

Spring Fairy

1 Use the felt-tip pens to draw your fairy's features. She is happy because spring is here!

2 Take half a pink fuzzy stick. Ask an adult to turn over the ends to make the fairy's arms and hands. Stick it to the back of the dolly peg and leave it to dry.

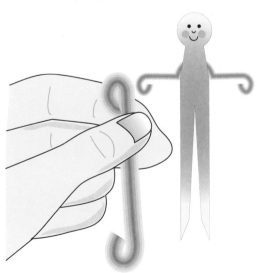

3 Take the orange thread. Fold it over and repeat until you have the desired length of hair, then glue to the dolly peg's head. Ask an adult to trim the ends with scissors to neaten when dry.

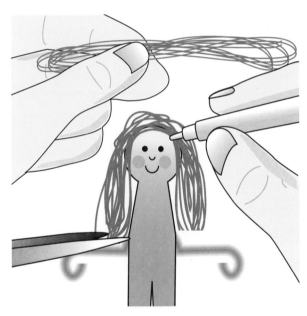

4 Take a sheet of yellow tissue paper. Ask an adult to cut it into four equal squares, as shown.

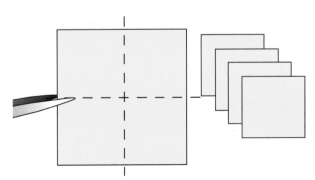

5 Take a square of tissue paper and fold it into a triangle. Fold it again, then once more, as shown. Ask an adult to snip off the right-hand point, then to cut out the zigzag pattern, as shown. Unfold the tissue to reveal a layer of the fairy's skirt. Repeat with the other three tissue squares.

6 Ask an adult to cut a slit from the edge to the centre of the two large flowers, as shown.

7 Spread a small ring of glue around your fairy's waist, and then layer the flowers and tissue circles to make her skirt.

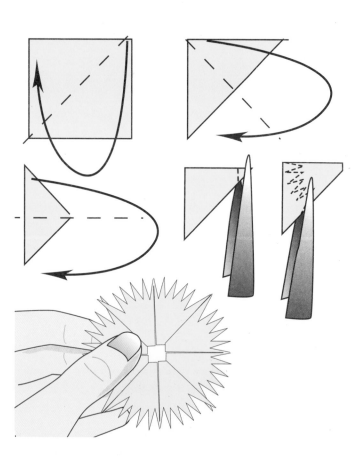

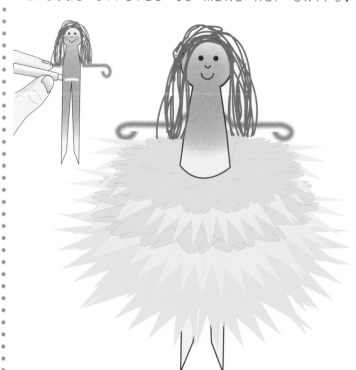

8 Take the length of ribbon and stick one end to the back of the fairy's waist. Carefully wind it around her body, along one arm, then back around and along the other arm. Wind the ribbon back into the middle, cut off any extra and glue down the end.

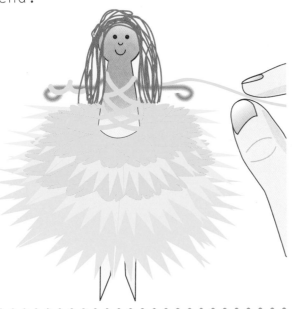

10 Make her shoes by using offcuts of ribbon. Place a small blob of glue on each foot, wind the ribbon around and stick it down. Decorate her outfit with beads if you want to.

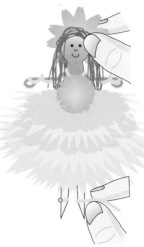

11 Ask an adult to bend the ends of the silver fuzzy stick into the centre, and to secure them by twisting them over one another. Bend the two loops into wing shapes and stick them to the back of your fairy.

9 Stick one small flower to the front of the fairy and one to the back to create her bodice. Add a flower to her head to make her hat. (See the finished look in step 10.)

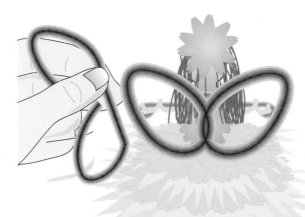

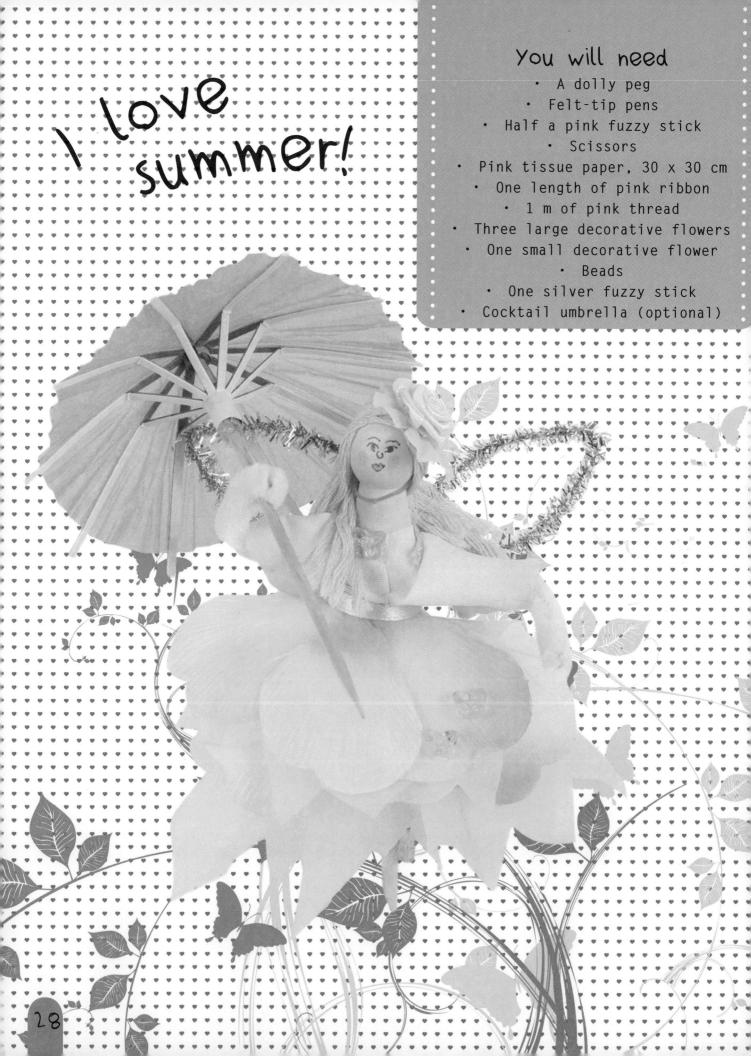

I love summer!

You will need
- A dolly peg
- Felt-tip pens
- Half a pink fuzzy stick
- Scissors
- Pink tissue paper, 30 x 30 cm
- One length of pink ribbon
- 1 m of pink thread
- Three large decorative flowers
- One small decorative flower
- Beads
- One silver fuzzy stick
- Cocktail umbrella (optional)

28

Summer Fairy

1 Use felt-tip pens to draw your fairy's features. Give her pretty rose-red lips.

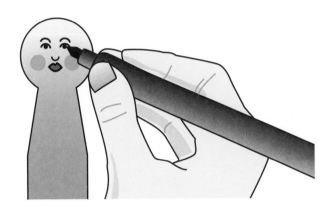

2 Take half a pink fuzzy stick. Ask an adult to turn over the ends to make the fairy's arms and hands. Stick it to the back of the dolly peg and leave it to dry.

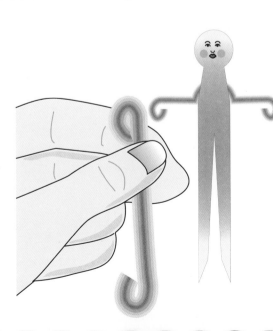

3 Take the pink thread. Fold it over and repeat until you have the desired length of hair, then glue to the dolly peg's head. Ask an adult to trim the ends with scissors to neaten when dry.

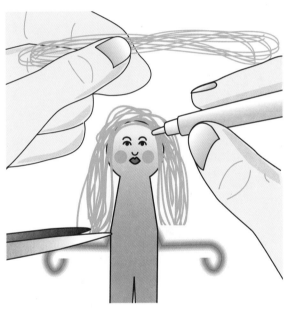

4 Take a sheet of tissue paper. Ask an adult to cut it into four equal squares, as shown.

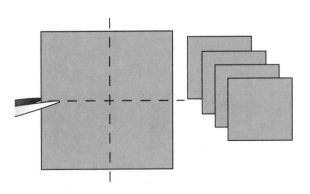

5 Take a square of tissue paper and fold it into a triangle. Fold it again, then once more, as shown. Ask an adult to snip off the right-hand point, then to cut out the zigzag pattern, as shown. Unfold the tissue to reveal a layer of the fairy's skirt. Repeat with the other three tissue squares.

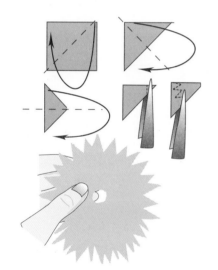

6 Ask an adult to cut a slit from the edge to the centre of two of the large flowers, as shown.

7 Spread a thin line of glue around your fairy's waist, then layer the flowers and tissue circles to make her pretty skirt.

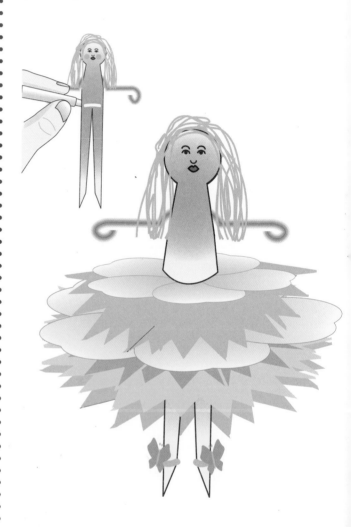

8 Use offcuts of ribbon to make her shoes. Place a small blob of glue on each foot, wind the ribbon around and stick it down.

9 Ask an adult to snip two petals from the other large flower. Fold them over the fairy's arms and glue the edges together to create her top.

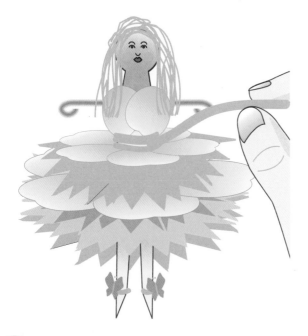

10 Take the length of ribbon and glue one end to the back of the fairy's waist, as above. Then wind it around her waist to make a belt and glue down the end. Decorate her outfit with beads if you want to.

11 Glue a small flower to your fairy's head to make a hat.

12 Ask an adult to bend the ends of the silver fuzzy stick into the centre, and to secure them by twisting them over one another. Bend the two loops into wing shapes and stick them to the back of your fairy.

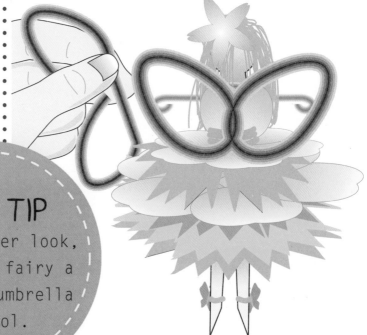

TOP TIP

For a summer look, give your fairy a cocktail umbrella parasol.

Crafty Ideas

Now that you have learnt how
to make dolly peg princesses and
fairies, you are ready to design
some of your own!

Extra sparkle

Remember to keep a lookout for scraps
of ribbon and material, beads, buttons,
broken jewellery, glitter and sequins.
Put them in a safe place for when
you want to make and decorate pretty
fairies and princesses of your own.

Create a scene

Why not create some colourful scenery
and put on a dolly peg princess or fairy
show. How about a glamorous ball or a
royal wedding? The possibilities are
endless, so just use your imagination.

Have fun!

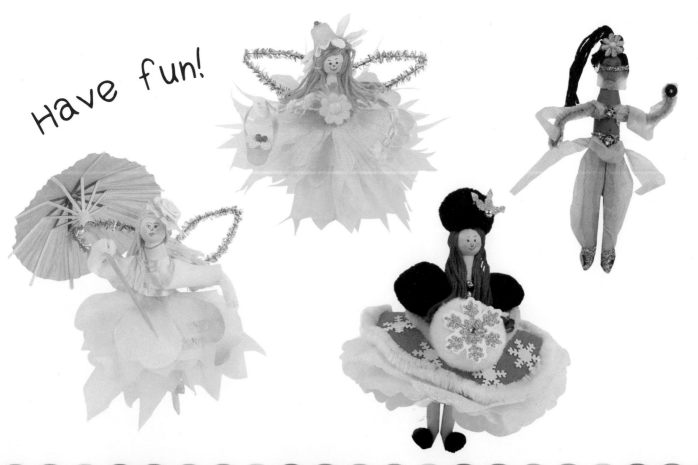